Salvador Dalí

D0287241

Titles in the series Critical Lives present the work of leading cultural figures of the modern period. Each book explores the life of the artist, writer, philosopher or architect in question and relates it to their major works.

Salvador Dalí

Mary Ann Caws

REAKTION BOOKS

Published by Reaktion Books Ltd
33 Great Sutton Street
London EC1V ODX, UK

www.reaktionbooks.co.uk

First published 2008

Copyright © Mary Ann Caws 2008

All rights reserved
No part of this publication may be reproduced, stored in a retrieval system,
or transmitted, in any form or by any means, electronic, mechanical,
photocopying, recording or otherwise, without the prior permission
of the publishers.

Printed and bound in Great Britain
by CPI/Antony Rowe, Chippenham, Wiltshire

British Library Cataloguing in Publication Data
Caws, Mary Ann
 Salvador Dali. – (Critical lives)
 1. Dali, Salvador, 1904–1989
 2. Painters – Spain – Biography
 3. Surrealism – Spain
 I. Title
 759.6

ISBN: 978 1 86189 383 3

Contents

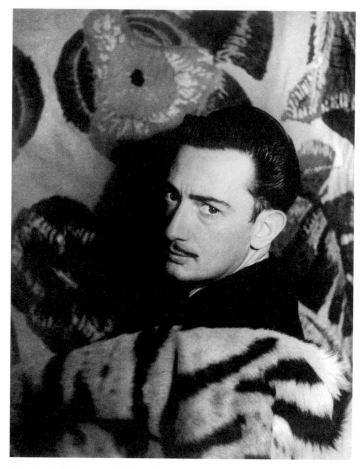

Salvador Dalí, photographed by Carl Van Vechten, 29 November 1939.

Introduction

All things come and go.
Hidden Faces[1]

Challenge

This concise and illustrated biography of Salvador Dalí came about
in a somewhat accidental fashion. I had researched and written,
for the same series, *Pablo Picasso*, and when I was approached with
the invitation to write this, I remembered the delight of that work.
A strange delight, to be sure – for there were and are, every day,
more commentaries on that icon of modernism. So the challenge
there was unimaginably steep, it seemed to me at the beginning.
But I ended up dwelling at some length on Picasso's relationship to
the poets with whom my work had been concerned for years, and
on the general atmosphere around the Bateau-Lavoir, Gertrude
Stein's salon, and the South of France. So I felt enlivened by the
light that Guillaume Apollinaire and Max Jacob in particular, and
even Antonin Artaud and Jean Cocteau (to take two wildly differ-
ent beings), shed on the life of Picasso, in letters and documents.

During this extensive research at the Picasso Archives in Paris,
I came across postcards and letters from Salvador Dalí to Picasso,
which, in all their outlandish spelling and graphic design, leapt off
the page at me . . . Some sort of prefatory signal, perhaps.

It was always, from the very beginning of my interest in the
Catalan painter, the writing that appealed to me. For years I would
extol Dalí's bizarre novel *Visages cachés* (*Hidden Faces*) to my
friends in English- and French-speaking countries, with nary a

reply in return. Surrealism incarnate, I would say, and so rich in details, more so indeed than any other of the Surrealist prose writers. Just look, for example, at the presentation of a foot so carefully observed by a painter-onlooker, plunged by the weight of his helmet into the depth of the scene:

> She had slipped off one shoe and placed her bare foot on the other. Baba looked for a long time at this arched foot, with its matt skin, its blue-tinged dimples . . . free of the stigma of the slightest redness touching or profaning its toes, of which each articulation of each phalanx seemed to rest on the ground beneath Raphael's approving glance, and as on the feet painted by him, the big toe was widely separated from the other toes . . . Baba looked, and one might have said that the weight of his leather helmet kept his large head bowed forward, obliging him thus to gaze down, so completely did his whole spirit seem absorbed in this contemplation.[2]

Or then look, in this novel again, at a set dinner-table scene:

> As if hypnotized, the Count looked at the Lilliputian images of his guests reflected in the concavities and convexities of the silver pieces. He observed with fascination the figures and faces of his friends, the most familiar ones becoming unrecognizable, while reassuming by virtue of the fortuitous metamorphoses of their rapid deformations the most unsuspected relationships and the most striking resemblances with the vanished personalities of their ancestors, mercilessly caricatured in the polychrome images that adorned the bottoms of the plates in which the dessert had just been served . . .
> Exactly as in the famous series of monstrous faces drawn by Leonardo, one could here observe each of the faces of the guests caught in the ferocious meshes of anamorphosis, twisting,

curling, extending, lengthening and transforming their lips into snouts, stretching their jaws, compressing their skulls and flattening their noses to the farthest heraldic and totemic vestiges of their own animality . . . As if in an instantaneous demonical flash one saw the dazzling teeth of a jackal in the divine face of an angel, and the studied eye of a chimpanzee would gleam savagely in the serene face of the philosopher . . .[3]

For me, this was the opposite side of the painter's 'soft watches' or 'moustaches', and I was hooked on Dalí's prose style. And then, last year, I learned about the existence of Dalí's own original version of his book *The Secret Life of Salvador Dalí*. Not the one his wife Gala had taken control of, but his own language and supremely odd spelling, sprawled across a many-paged book: *La Vie secrète de Salvador Dalí: Suis-un génie?*[4] Of course I ordered it several times from France; it never came, and I forgot all about my curiosity. However, one day in Bordeaux, I wandered into the bookstore and found, to my immense surprise, the large volume, brought it to the plane, and was captured, seduced in fact, by the strangeness of it all.

So I undertook this work, and have greatly enjoyed the oddnesses of it – more the writing than the paintings – for that is stranger still. I have tried here to emphasize some of the high points within it, including, of course, the differences between the Gala version and the Dalí version of his *Secret Life* (followed by the Re-Secret Life, or the *Diary of a Genius*). Other writings grabbed me, and I have followed their traces here.

Everything about García Lorca has always fascinated me, and so I place special stress on his relationship to Dalí, on the writings by both – including letters and poems – and the way in which Lorca appears and reappears in Dalí's paintings. As a worker in the field of Surrealism, I was already bound to be drawn to the Surrealist aspect of Dalí, but there was something else. Apart from sketching out the high points of his life and his perpetual involvement in art,

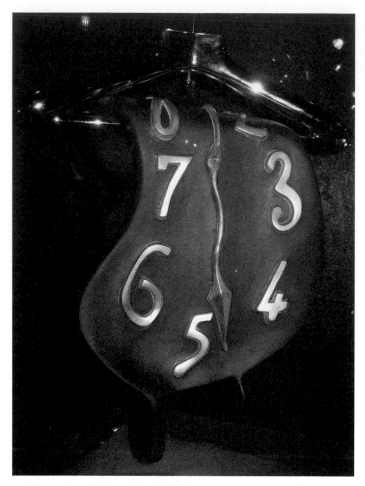

Installation shot of 'soft clock' at Figueres.

and his elaborate formulation of his own appearance and charac-
ter, I found myself paying particular attention to the ten years of
his major work, as the other biographers and commentators on
him have done: I am thinking of Ian Gibson, Dawn Adès and
Haim Finkelstein. Having lived for many years in the Vaucluse

near Robert Descharnes – a world-class authority on Salvador Dalí and much involved with his business in the later years – I was especially interested in all the tensions around the work, the heritage and the person.

But as I continued writing and reading and looking and thinking, three points of view swam into my ken, and into the following text. The way of detail – what a genius was Dalí with that, from the microscopic out to the macroscopic! – the way of the Magic Secrets of the craft of art – what ironies, how delightful! – and finally, the highways and byways of his filmic experience, from the early ventures with Buñuel to the late one with Disney, and some in between, realized and not.

Dalí is fun. I met him only once, on the street, in a green plush suit with, yes, his moustaches twirled perfectly, Gala by his side, grey-faced, expressionless. Like a game of charades it felt. Ah, I would have liked to have seen him in his diving-bell suit, would have liked to watch his issuing forth from the Bonwit Teller window after his bathtub concoction of a Surrealist display was ill-treated, would have liked to hear him ring the set of bells he carried in his pocket to attract attention, would have liked to have been looking, with Edward James the collector and Gala the other kind of collector, for four-leaf clovers in the grass of the Thrall Soby estate . . . but as it is, I've liked looking again at the works of the artist and the writer. He too preferred his writing to his painting, and that gives cheer to the biographer who shares this preference.

In answer to a question asked on French television by Jean-Pierre Lannes in 1964, 'Tell me, Salvador Dalí, are you God?', Dalí gave the following answer:

No, not at all. After all, Dalí is intelligent and God is not. He will always be the Supreme Creator and therefore the exact opposite of intelligence. Dalí happens to be gifted with much talent, yet is a bad painter, an abominable artist. This may seem a paradox,

but it really is a vicious circle. In creating the universe, God also made the human being and gave it the only power that is not divine: that of speculation. Ironically, this is expressed in nuclear physics and biological experiments that make human intelligence come close to the reality of the idea of God. You do understand me, don't you?[5]

Living Places

Nothing is so radically associated with Dalí's work and life as the places he cared about and inhabited. They are indelibly marked with his larger-than-life figure, reputation, and – of course – myth-making. Since it does not, always, in the case of Dalí, seem enormously important to separate the myth from the 'real' and his construction of his public personality from the private one, or from the factual elements of time, place and event, it is of enduring fascination to see them merge. Far beyond the signature moustaches of the painter and the velvet bow for Gala's hair (preserved in her domain, the Castell Gala Dalí in Púbol, about 30 km south of Figueres, Dalí's birthplace), there is a kind of apparent and deliberate too-muchness in all the constructions, including the permanent Dalí collection in the Museo Real Circulo Artistico Barcelona, on the Carrer Arcs in the Gothic Quarter. Here, from the Clot Collection, there are immense statues, like the one of *Gala Leaning Out of the Window* and an *Icarus* and other looming forms, classic, like *Trajan on Horseback,* literary like *Don Quixote.*

Far better known is the outlandish Teatre-Museu Dalí, in Figueres, that smallish town just an hour and a half's train ride north from Barcelona, where you can see the artist's birthplace, Carrer Monturiol 6, and the place his family moved to, just down that street. You can stare at the smaller dining room near the larger one in the Hotel Duran at Carrer Lasauca 5, the 'Celler de Ca la Teta', where Dalí and his *bande à Dalí* took their meals, Dalí often

serving pink cava, and preferring the products of the winery Castillo Perelada in Perelada – run by Miguel Mateo, friend of Franco, who was good at getting Dalí out of scrapes (like the time he tore up an official notice from a notary, who had had the inestimable unintelligence of arriving at siesta time; strange as this seems, for those of us who live in France's Provence, it is totally understandable).

In the truly extraordinary Teatre-Museu Dalí (Spanish: Teatro Museo) in Figueres, Catalonia, dreamed of in 1961 and finished in 1974, a glorious kitsch rules – objects in every conceivable corner and place, and many inconceivable ones, statues standing in every window saluting other statues in other windows and on the roof. In the courtyard, the construction called *Carnaval*, a Cadillac with a figure inside, as in Dalí's celebrated *Rainy Taxi* – what, there's a boat too? Yes, and atop the Cadillac, yet another statue – plump isn't the word for it, think Maillol. (Over the years, Dalí and Gala had many Cadillacs, and a blue one remains in the garage at Púbol. This is the one that transported Dalí to the hospital after the fire there.) What should be playing in this courtyard but Wagner's *Tristan und Isolde?* As it is also in the Castell Gala Dalí at Púbol, where the swimming pool is graced by multiple faces of Wagner. Dalí said of the great German composer: 'His music demands its first place . . . Nobody has had such a complete idea of the theatrical lyricism with its images, its myths and simulations, to the extent that we can affirm without fear of error: Wagner is not only a mountain of geological melodies, but also and above all a veritable mountain of mythological images and hallucinations.'[6]

As for Púbol, and the 'castell' or 'castle' (read, large house), it adjoins a church, which used, as was the custom, to correspond with the house so the nobles could hear Mass without disturbing themselves. The purchase of the place was strangely prefigured by Dalí and Gala's religious wedding in August 1958 (they had had a previous civil marriage), at the church of Els Àngels, in Sant Martí

Vell, near Púbol. When, in 1961, Dalí dreamed up the Teatre-Museu in Figueres, he also thought of managing to have a separate place for Gala, and after several investigations, including some aerial ones, located the Castell of Púbol, of Gothic–Renaissance style. He purchased it in 1968, and it was opened to the public in 1996. In 1983 Dalí had the walls heightened by half a metre so as to protect their privacy. Gala and Dalí each had their own space, worked out in a deliberately constructed myth and fact. She spent only a few weeks in Púbol each year between 1971 and 1980. There, the house-keeper Dolors Bosch took care of all the work, and Artur Caminada, of the driving. Gala had driven her own car off the road between Port Lligat on the coast at Cadaqués and Púbol to the south, and at that point began to be driven around in her orange Datsun.

The Castell was, very largely, shaped to do honour to her every wish. There were several radiators (necessary sometimes, after all), the sight of which Gala disliked. So they were usually covered with screens of wicker. But in the celebrated piano room (on that piano Jeff Fenholt – not just Jesus Christ Superstar, but a musician who wanted to form a group – and the young French philosopher Michel Pastore, among others, liked to play), Dalí painted two radiators in oil on a metal door hiding the real radiators. A very nice touch.

In the Castell, Dalí could only visit her with her permission, just as it works in his novel of 1944, *Hidden Faces*: another pre-figuration, like the religious marriage nearby. Veronica, who is gifted with 'an iron spike of a will',[7] says to her husband, the Count Grandsailles, after a bitter argument, that she wants a place for her solitude, to which he will only have access if she permits. Grandsailles gives her the key, and promises never to enter unless she chooses.

It is Antoni Pitxot (Antonio Pichot) who now is in charge of the Teatre-Museu, and nearby, in Cadaqués, you can see the house where the Pichot family lived and where the Dalís visited every

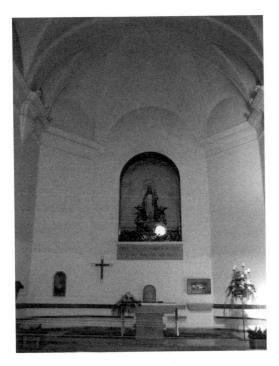

The church of Els Àngels, where Dalí and Gala were married on 8 August 1958.

summer. Ramon the uncle was a friend of Picasso, and the family Pichot was a close one. The name is Pitxot in Catalan, that lovely language Dalí spoke when he was not discoursing in his appealingly bizarre French, the spelling of which is part of the attraction of the new publication of his *Secret Life*. The beach at Cadaqués, called Es Llaner, was the preferred playing place when García Lorca came to visit, and Buñuel, and Marcel Duchamp. When Dalí and Gala bought the fishing cottage at Port Lligat in 1929, and then the successive cottages linked to it, the fishing tradition was never unlinked from the house – on one of whose doors the local fishermen used to clean their paintbrushes. Dalí, on many occasions, repeated: 'I want to return to the best place in the world, to Cadaqués', which motto the Hotel La Residencia in Cadaqués has

placed by its own front door. And the simplicity of life in Port Lligat greatly appealed to him. So beyond the costume: the cape, the moustache, the unmistakable appearance, there was this too. He loved to be photographed in his red Catalan cap or *birettina*, and his favourite cowboy shirt, blue, with brown inserts, so often worn it was almost worn out. And this Salvador Dalí is as real as the other – this is the one I encountered, and finally cared to write about.

> In Port Lligat I take care of my orchard and my boat: in other words, of the canvas I am finishing. Like a good worker, I covet simple things: eating grilled sardines and strolling with Gala along the beach at sunset and seeing how the Gothic rocks are transformed into nightmares by the darkness . . . I need to be in Port Lligat, to see the sailors, the colour of the olive trees and the bread, to feel the landscape, with its unction and inner peace.[8]

It was at Port Lligat that Dalí and Gala spent most of their time, with various comings and goings. When Gala died there in 1982, her body was taken to Púbol to be embalmed and buried in the crypt, whose floor resembled a chessboard, with white and black squares. It is called a *delme*, as with the tithes the peasants used to bring to the nobles who owned the Castell. When the townspeople were having their celebratory dance, the *Sardana*, and the weather was bad, Gala had not only permitted them to use her crypt, but contributed funds towards the celebration. Two simple stone slabs were placed there, one for her and one for Dalí, who never occupied it, preferring to be buried in the Torre Galatea of the Teatre-Museu in Figueres. Her funeral was attended by few people; Dalí was not among them, but descended to the crypt that night.

He spent the next two years in her room, in her ex-bed, refusing to eat: Juame Subiros, the chef of the dining room at the Hotel

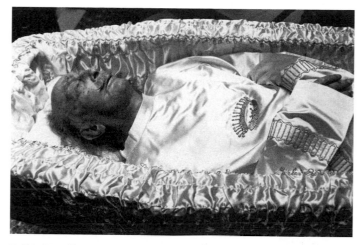

Dalí in his coffin, 1989.

Empordà, would send him delicacies such as mint sherbet all the 40 kilometres between Figueres and Púbol, and from Cadaqués, he would be sent his favourite food of sea urchins. One night in 1984, leaning too many times on the bell with which he summoned his nurses, he caused a fire, in which he was badly burned. For the necessary trip to the Clínica del Pilar in Barcelona, the Cadillac in the garage was used instead of an ambulance. Dalí wanted to stop by his beloved Teatre-Museu there, which he did, and then after his hospital stay, he was taken back to the Teatre-Museu from which he never emerged, dying on 23 January 1989. There, his tomb is placed directly under the dome, as he wished.

As for Port Lligat, the place he had so loved for so many years, where he had painted so much, it was not opened to the public until 1997. Dalí never went back there after Gala's death, nor did he ever return to Púbol. There had been 53 years of life with Gala, and despite their thunderous ups and downs, and their individual ways of comporting themselves in their deliciously scandalous private and not so private lives, they had been a pair.

1

Birth of a Genius, 1904–16

Salvador Dalí said he was to be a genius from early on. And that is exactly what many have come to think he was. In Cadaqués, Spain's equivalent of France's Pointe du Raz and of Land's End in Britain, everything is different from everywhere else. The dances, the colours, the version of Catalan spoken (*salat*), and the rest. Indeed, Salvador Dalí was himself always different: he claimed to be descended from the Moors, and ascribed his love of excess and luxury to that heritage.

That Dalí's father, Salvador Dalí Cusí, was born out of wedlock, on 25 October 1872 to Gal Josep Salvador and Teresa Cusí Marcó, was not widely spoken of. Nor was the fact that the grandfather was a maker of cork stoppers for casks (a useful and lucrative job, Cadaqués being active in the export of olives and anchovies). Instead, according to Dalí's father, he was a doctor. Myths run in the family. Gal ran a horse-drawn carriage between Figueres and Cadaqués on the coast.

All over this part of Spain the *tramuntana* wind (Provence's *tramontane*) blows fiercely, and legend has it that Gal moved to Barcelona in 1881 to escape this bitter north wind. But its particular harsh light and sharp outlining of objects was to remain in the future painter's work. Gal Dalí was a victim of the bad days of the Barcelona stock exchange, and already subject to a sort of persecution mania. Screaming that there were thieves after him one April day in 1886, he tried to throw himself from the third-floor balcony of his apartment, but was prevented by the police. Six days after he

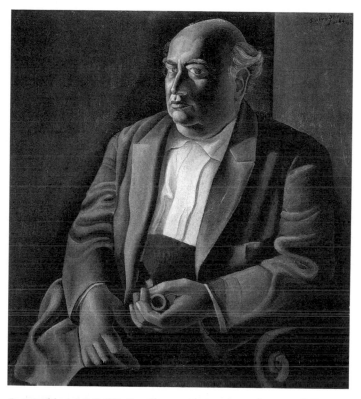

Portrait of the Artist's Father, 1925, oil on canvas.

managed to do so, the very day that he was, at the age of 36, about
to be placed in an insane asylum. More secrets: his name was not
published in the newspapers; he was said to have died of a brain
trauma, and was given a Catholic burial. No one spoke of this, no
more than of the out-of-wedlock birth of his son. Nor does the
painter mention this anywhere, in speaking or writing. It could be
safely assumed, of course, that his fascination with the development
of his 'paranoiac-critical' method in the 1930s was somewhat aided
by this series of events: you don't speak of them, but they control
what you see, think, and create.

Secrecy and religion often make a good marriage. Salvador, the painter's father, was not only Catholic in his leanings, but intensely Catalanist. Madrid was chaotic, Spanish-speaking, repressed; whereas in Barcelona there was the immensely original work of Antoni Gaudí, Art Nouveau with a vengeance, and the beautiful Catalan language. In Barcelona Salvador's father became closely linked with the Josep Pichot Gironés family, and this was to matter greatly in the painter's life. Antonia Gironés, the mother of the Pichot clan, owned a promontory called Es Sortell, near Cadaqués. The two families saw a great deal of each other. Ramón, one of the seven children, was a painter, and a close friend of Pablo Picasso, nine years his junior. Not only that, Miguel Utrillo, a painter friend of both Ramón and Picasso, was the person who brought shadow theatre (a concept he imported from the Chat Noir in Paris) to Els Quatre Gats.[1]

The Pichot family's house in Es Sortell by the sea was also important to the Dalí family. A photo of the Pichots there shows Pichot's wife, Laure Gargallo ('Germaine'), whom Picasso's friend Casagemas committed suicide over. He was impotent, and Picasso, who was probably also her lover, painted the very moving painting of Casagemas following his suicide over her non-responsiveness to his love. The group of Barcelona painters hung out – the relations between Picasso and the younger Dalí have never been fully elaborated, but they were in Figueres at the same time, in the summer of 1910, when Picasso visited Ramón with Fernande Olivier, a visit Dalí might well have heard about. Both Picasso and Dalí were close to Ramón and the Pichot family, and later – this we know from Dalí's own account – Picasso himself was the first 'monument' Dalí visited in Paris, even before the Louvre. So Barcelona mattered a lot. In that great city, where the Dalís would go at Christmastime, Gaudí's elaborate and brightly coloured mosaics on the benches of the Parc Güell could not help but fascinate the young Dalí.

In 1900 Salvador Dalí's father became the notary of Figueres, the capital of the Ampurdán region. Salvador and his wife Felipa gave birth first to a Salvador Galo Anselmo, who was to die at twenty-two months of gastro-enteritis. This first Salvador haunted the memory of the painter, born nine months and ten days later, who states in his *Secret Life*, that his brother died at seven, not twenty-two months, of gastro-enteritis. At one point, in his *Unspeakable Confessions*, he claims that since his parents kept a photo of the dead Salvador in their bedroom, right next to a reproduction of a painting of Christ by Velázquez (always Dalí's favourite painter), and had given him, the new Salvador, the name of the dead one, it was impossible to live up to that idea so clearly marked out. His dead brother was certainly to have been a genius, so how could he be that? On the other hand, as he will always say, that is exactly what he was to be: a genius.

There is an interesting point of view about the relation of the two brothers, having to do with the profane and the sacred, partially inspired by Dalí's statement in the *Diary of a Genius* that his 1950s art of 'nuclear mysticism' was 'merely the fruit, inspired by the Holy Ghost, of the demoniacal and Surrealist experiments' of the first part of his life.[2] The book's foreword calls the *Diary* 'an ode to the splendor of tradition, the Catholic, Hierarchy, and Monarchy', in line with Dalí's describing himself as 'Roman Catholic, Apostolic, and Monarchic'.[3] It might be thought that Dalí was deliberately creating another self from this dead brother: 'Alongside Dalí's decadent, difficult, angst-ridden, anarchic, monomaniac Self, we must always remember his sleeping, pure, idealized, innocent brother.' So he set himself up as the profane Self in contrast with his brother's 'sacred Other'.[4]

The Dalís lived at Carrer Monturiol 6 for the first 10 years of the painter's life. How grand: for there was a balcony full of lilies and spikenard, and a few canaries, all of this overlooking a garden with nightingales and chestnut and eucalyptus trees. Right

Dalí's birthplace
on Carrer
Monturiol in
Figueres.

beneath the Dalí apartment was that of the Matas family, who
lived a life of great elegance and had – oh the luxury of it – a
wrought-iron railing for their balcony. All this before they departed
in 1911 for Barcelona. On the Dalí balcony the future painter drew
very small swans and ducks by scratching off red paint from a
table . . . He loved drawing, he loved the cinema, he loved being a
spoiled child, and he did, as he sometimes said he did and some-
times said he didn't, place his excrement around the apartment . . .
Whether he did or didn't, he is surely one of the most excrement-
obsessed painters there ever was, and this was not the Chris Ofili
dung of sacred stuff with which New Yorkers became acquainted
during one of the former mayor's quarrels with modern art in
Brooklyn. The excrement-obsession of Salvador Dalí was to last

through his entire career, marking garments and undergarments in his paintings throughout.

As for the balcony, it was lost, and the smell of the flowers in the garden, but was replaced by a high-flying situation. In July of 1912 the family moved to the nearby address of Carrer Monturiol 10, and the balcony was replaced by a rooftop terrace, height being and remaining a major issue in the painter's life.

> And what is the high? The high is exactly the contrary of the low . . . What is the low? The low is: chaos, the mass, the collective, promiscuity, the child, the common fund of the obscure folly of humanity, anarchy, the low is the left. To the right, above, one finds monarchy, the cupola, hierarchy, architecture and the angel.[5]

Here, in a deserted laundry room, he put a chair in the abandoned trough, placed his working instruments on the scrubbing board over the top, and doused himself with water when it was hot. Here also he put his collection of Gowan's Art Books, small volumes given to him by his father, in which the reproductions of basic paintings (Titian, Claude, Watteau . . .) were to give the young painter his first and enduring taste of the Great Masters.

His first teacher was Esteban Trayter at the primary school, a school for poor children which Salvador attended, beautifully dressed – always set apart, from the beginning. Trayter helped him unlearn the alphabet. So, said Dalí later, he never consulted a dictionary in alphabetical order, but just opened the pages at random, far more interesting and revelatory.

> I always find what I'm looking for, alphabetical order is not my speciality, and I have the gift of always being outside, so I was going to put myself outside the alphabetical order of surrealism because, whether I wanted or not, 'surrealism was me'.[6]

The place to
which Dalí's
family moved
in 1912, Carrer
Monturiol 10.

Surrealism was himself, to himself, of course. More about that
later.

Monsieur Trayter caressed young Dalí's chin and squeezed it
between his index finger and his thumb, 'which had a smooth skin,
the smell and temperature and roughness of a wrinkled potato
heated by the sun and already a little rotted'.[7] Trayter was an atheist,
a Francophile, and a collector of stereoscopic instruments and pic-
tures. Dalí was always fascinated by optical illusions and claimed
in the *Secret Life* that a little Russian girl in one of Trayter's pictures
was the prescient representation of Gala, his future Russian wife.

But more important still was a child called Butchaques ('pockets'),
handsome, alluring, blonde-haired, blue-eyed, and a perfect
model for Dalí's obsession. Dalí blushed easily, and was deeply

embarrassed by it. Here is his description of being touched by this gorgeous creature one day. A simple pat on the shoulder provokes the following reaction: he jumps, swallows his saliva the wrong way, coughs, and is glad that makes his emotion less obvious: 'I had in fact just blushed crimson on identifying the child who was touching me as Butchaques.'[8] This fear of blushing endures throughout Salvador's life, as does his fascination with buttocks: look at the *The Lugubrious Game* (1929), where Butchaques seems represented. In this painting, the pants are soiled with excrement, a fact that Dalí enjoys commenting upon at great length and often.

As a child, he spent a great number of hours in his home contemplating a part of the ceiling with its brown moisture stains. Like the teaching of Leonardo concerning the marvellous stimulation to the artistic mind of a stain on a wall, he was never to forget the emotional impact of those stains. But when they became too familiar, they would lose all their interest for him, and he would let them metamorphose into something else. Always the amazing shapes of the rocks at nearby Cape Creus would remind him of the artistic impulse developed by the observation of these stains as they changed their shape in his mind.

Dalí's early landscapes remained, like these rocks. Their harsh contours gave rise to the entire mythology of hard and soft: baroque and soft (like the all-too-famous soft watches), Gothic and hard, and to the overwhelmingly important idea and vision of the double image. *The Great Masturbator* can be seen in this light. Dalí was finally to live in the fishing village near those rocks, in Port Lligat.

All his life Dalí spoke French, with a heavy Catalan accent, and wrote in French. This was because his father had decided, after two years with Trayter, where the teaching was in Spanish, to enrol him in a college run by the Christian Brothers, a French teaching order, which had been forbidden from having schools in France. The teaching was in French, and both Dalí brothers had done well already in French at school before. Dalí spent six years in the school.

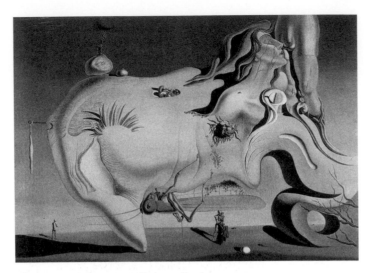

The Great Masturbator, 1929, oil on canvas.

Not so in his *Secret Life*, where he claims to have spent only two years there, and never says the Christian Brothers are French. For him, the art of writing and the art of lying seem to have become indistinguishable.

At school with the Christian Brothers, the art teacher enjoined the students to be careful: for example, never to go over the line. Dalí's great detail in his paintings and drawings may reflect that. No less important was the art on the wall: Millet's *The Angelus*, which would serve as the focus for one of Dalí's most crucial works, the *Architectonic Angelus of Millet*, 1933. The entire class had to repeat a prayer each evening at the sounding of the Angelus bell. As Gala was to point out, twilight was the favourite time for the painter, always.

Deaths marked his young life: his brother, the first Salvador, having died of gastro-enteritis at twenty-two months, and his aunt to whom he was close, Carolina Barnadas Ferrés ('Carolineta'), died when Dalí was ten. When the blue telegram arrived, the family

The Lugubrious Game, 1929, oil and collage on cardboard.

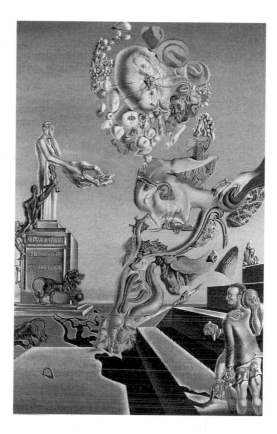

began to wail, and the highly sensitive Salvador was never to forget that. Another unforgettable and terrible occasion, marking his future life, was his father's arriving home late one day, shouting 'I've crapped'. The shame of this and the subsequent trauma of mortification show in the soiled pants visible in *The Lugubrious Game* of 1929. Such sights seem to have marked him substantially: a glimpse of his father's robust penis, somehow exiting from his pants in a sidewalk struggle; the young Julia Pichot's white thighs and underclothes, all of these leading to the shame he always associated with such striking visions.

But the least forgettable thing was the glory of his birth. His salute to it, while ironic in its over-the-top-ness, is all the same worth quoting:

> Let all the bells ring! Let the toiling peasant straighten for a moment the ankylosed curve of his anonymous back [shades of *The Angelus* of Millet here] . . . Look! Salvador Dalí has just been born! No wind blows and the May sky is without a single cloud . . . It is on mornings such as this that the Greeks and the Phoenicians must have disembarked in the bays of Rosas and of Ampurias, in order to come and prepare the bed of civilization and the clean, white and theatrical sheets of my birth . . .[9]

In fact, the entire bulk of his *Secret Life* is presented as something worthy of our consumption, because of its astounding nature, to justify its length:

> Listen patiently, therefore, to the account of the amazing and dramatic circumstances which surrounded the new encounter with the fetish of my deliria. It is well worth your while.[10]

And patience is indeed what it takes. From time to time he will let us know how much of the book we have gotten through, or then summarize his situation so far as we have gone: he has done this and that, been thrown out of school, has become an anarchist, a monarchist, an anti-Catalonian, has almost died in inventing a 'counter-submarine! How great he is! Look how great Salvador Dalí is!'[11]

2

Precocious Painting, 1917–21

In June 1916, aged twelve, Dalí passed the exam for the Figueres
Instituto and went to stay with the Pichots at the 'Tower Mill'
(Molí de la Torre) just outside Figueres. The painting of Ramón
Pichot continued to dazzle him, like a discovery of French
Impressionism, which he described as 'the school of painting
which has in fact made the deepest impression on me in my life
because it represented my first contact with an anti-academic and
revolutionary aesthetic theory. I did not have eyes enough to see all
that I wanted to see in those thick and formless daubs of paint . . .'[1]
The eroticism of all this paint 'burned deep in my throat like a
drop of Armagnac swallowed the wrong way'.[2] What he learned,
among other things, from the contemplation of this riot of colour
was never to use black, as it was not a colour.

Later, when he was acquainted with the landscapes of Joaquim
Mir, a member with Isidro Nonell of the 'Saffron Group', because
of the yellow tones of their painting, he was to move away from
this fascination with Impressionism towards an interest in
machines and gradually to Futurism. By the end of 1918 he was
writing as compulsively as he was painting. The writer Gabriel
Alomar, a friend of the great Rubén Darío, found that he had
literary promise, as indeed he did. He had begun with a love
of twilights, and his prose poem titled 'Twilight' was couched in
the late Symbolist style and vision of Juan Ramón Jiménez and
Antonio Machado. Still under the influence of Ramón Pichot,

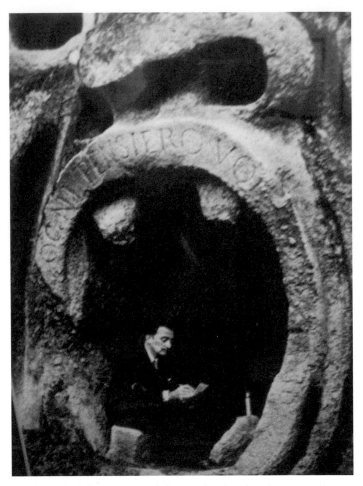

Dalí sitting in a grotto in the gardens of the Villa Orsini, Bomarzo, north of Rome.

he found himself particularly drawn to sunsets, to such sights as
the view from the tower over the Empordà plain. Everything about
the Empordà was to matter to him greatly: it is to be noted that his
early exposure to poetry beyond Spain came from a 1920 issue of
the journal *Alt Empordà*, on European poetry. At this young age he

had already planned a novel, to be called *Summer Afternoons*, reminding us of Henry James's favourite expression, 'summer afternoon' – the two words he and James found the most beautiful in the English language.

His father had also enrolled him, simultaneously, in the Marist Brothers' College on the Rambla, in accordance with the long tradition of enrolment in both state and private schools. At the Instituto he was privileged to have the superb drawing teacher Juan Nuñez Fernández, whom he always credited with being his very best teacher. Dalí often did the exact opposite of what he was told, working not with the soft pencil and the slight brushing of the very white paper which Nuñez recommended, but with black and heavy pencils, and such passion that everyone gathered to watch. Then he would scratch the paper to bring out the fibres, rub the paper to smudge it and in painting, pile the colour upon itself to bring out the luminosity and stick on some small stones, over which he would paint. This he called his 'stone period'.

After a great success in the drawing competition, his father gave him both an exhibition and a splendid *garotada* or feast of sea urchins on the terrace. What a culminating triumph. For the 'sacred tabernacle of his palate', sea urchins were always his favourite dish, of which he might eat three dozen at a sitting. He would not eat oysters detached from their shells and served separately, because of their formlessness, but any soft edible surrounded by a shell-like armour he loved. The well-known saying of André Breton, 'La beauté sera convulsive ou ne sera pas' ('Beauty will be convulsive or will not be'), Dalí would transmogrify into 'Beauty will be comestible or will not be'. References to food are everywhere in the Dalínian universe. Dalí loathed the clinging of the soft, such as spinach, to the teeth, and preferred to eat things out of their armour, such as shellfish. 'Nothing can be regarded as too slimy, gelatinous, quivering, indeterminate or ignominious to be desired.'[3] Besides, the refuge of the slimy and soft inside the

protective armour is like the cosiness of the womb, that 'initial paradisal state'.[4] Thus his frequent and solemn ingestion of crabs and clams, and his half-ironical salute to the lobster, especially when it was a lobster-telephone.

> Telephone frappé, mint-colored telephone, aphrodisiac telephone, lobster-telephone, telephone sheathed in sable . . . telephones on the leash which would walk about, screwed to the back of a living turtle . . . telephones . . . telephones . . . telephones.[5]

Dalí would down, at a sitting, cod with tomato sauce, squab, rabbit, and then several martinis or glasses of champagne . . . and everything is recounted at length. The idea of moving to Arcachon, near Bordeaux, during the war, brought him the ideas of 'jugged hare, duck liver aux raisins, duck aux oranges, and *huîtres de claire* in Arcachon'.[6] Snails were a special delight, and he was to pay Freud the high compliment of finding his cranium to be a snail, in the form of a spiral – a discovery that had an impact on his portrait of Freud made a year before the psychoanalyst's death.[7]

The extreme sensuality of his encounters with food was always to be recounted in detail. Often, his crutch, like the sceptre of the king he imagined himself to be, would provide the necessary probe to his experience. Two things, he said, crutches and cherries, would focus his attention during his entire life (see the cherries painted on the door, and the worm exchange, in another chapter): 'The superb crutch! . . . the height of authority and solemnity.'[8] He would stick it into an object or an animal, and then dip it in a stream, and then take it to the top of his tower at twilight to purify it by night and dawn's dew . . . Prodded by his crutch, a melon spatters its intensely sweet fluid over his tongue, increasing his dizzy delight to a kind of delirium, as he looks at the melon and then a window in which a woman's body is outlined: 'Melon, window! Melon, window!

Window, melon!'[9] Or he would deliberately spill his *café au lait* down his neck and chest and belly, coating his skin with a sticky moisture. He loved all cheeses that resembled his soft watches, like Camembert, and was overcome, going to New York the first time, by its rising before him 'verdigris, pink and cream-white. It looked like an immense Gothic Roquefort cheese. I love Roquefort, and I exclaimed "New York salutes me!"'[10] (And he loved the poetry of New York, 'old and violent as the world . . . it is seething biology . . . it is calves' lungs, on which the subways run . . .')[11] In the period in which he especially loved olive oil, he would put it all over everything in the morning, he would dip his toast in oil laden with anchovies, drinking the rest and pouring the last drops on his head and chest – and crediting it for the powerful growth of his hair in its 'swampy blackness'.[12]

His passion for his paints as well as his painting was already balanced by the things he feared more than anything. For example, the very idea as well as the actuality of locusts. In his French original version of *The Secret Life*, he uses, instead of the Spanish *llagosta de camp*, the French word *sauterelles*, generally translated as 'grasshoppers', thus the frequent confusion. At the sight of the smallest locust he would shield himself with his arms or faint, or a few significant times, hurl himself off a staircase. He even invented a brilliant *counter-locust*, when he would persuade his opponents that what he really feared was a sort of paper bird . . .

Dalí's special fascinations in turn fascinate the reader inescapably: certain paintings – those of Goya, in particular the Black Paintings – and with certain readings, especially Voltaire's *Philosophical Dictionary* and Nietzsche's *Thus Spake Zarathustra* were to matter greatly. All this is documented in his various diaries of the period, as is his obsessive involvement with not just paints but the very idea of paints. In May 1920, just before his summer vacation in Cadaqués, he reflected on the joys of his material for painting, and all their possibilities:

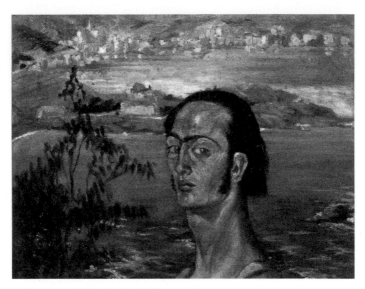

Self-portrait with the Neck of Raphael, 1921, oil on canvas.

As soon as I was ready, I opened the cupboard in my room and carefully took out some boxes. I opened them. They had the tubes of paint. Those clean and shiny tubes represented for me a whole world of aspirations, and I look at them and caressed them with hands trembling with emotion, just as I imagine lovers do. . . . And I saw my tubes emptying their pure colours onto the palette, and my brushes catching them up lovingly. I saw my work progressing. The suffering in creation. My ecstasy as I lost myself in the mystery of light, of colour, of life. . . . More light, more blue . . . more sun . . . losing myself in Nature, being her submissive disciple . . . Oh, I could go mad![13]

And even at this early period, his assurance about his future is over the top: 'I'll be a genius, and the world will admire me. Perhaps I'll be despised and misunderstood, but I'll be a genius, a great genius, I'm certain of it . . .'[14] That certitude he had always with him,

although he was sometimes to date its inception differently. 'Since 1929', he says in his *Secret Life*, 'I have had a very clear consciousness of my genius, and I confess that this conviction, ever more deeply rooted in my mind, has never excited in me emotions of the kind called sublime; nevertheless, I must admit that it occasionally affords me an extremely pleasurable feeling.'[15]

It mattered that his appearance was always unlike that of anyone else. From the time when he used to dress more elaborately than the other children in the state school to the time when, late in life, he would always carry a set of bells to draw attention to himself ('How else would I be sure they would notice me?'), he never forgot to be and to look like Dalí; he would pay careful attention to what he was perceived as, always wanted to be the Other, to 'make myself look unusual'.[16] He loved disguises of all sorts, and wanted attention to be drawn to himself, whatever his disguise – how strangely this contrasts with his excessive timidity as a young person, we would think. But of course, it is simply the other side of that

The Enigma of Desire, or My Mother, My Mother, My Mother, 1929, oil on canvas.

self-consciousness. He would carry about a book with an eye-catching cover, to be noticed: he hadn't read *The Conquest of Bread* by Prince Kropotkin, but thought it likely to make him appear interesting when he walked about.

What was of immense importance to him was always his appearance. He was to acknowledge himself as a *poseur*. He modelled himself on the hero of Ramón del Valle-Inclán's *Summer Sonata*, inscribing his 'thoughts about myself' in his diary of October 1921: 'I'm a "poseur" in my manner of dressing, in my manner of talking and even in my manner of painting, in certain cases . . . I am madly in love with myself.'[17] He was not the only one in love with Salvador: there was a girl in Figueres, Carme Roget, whose father owned the Emporium café there (which is still in business today), who was in love with him until he left for Madrid.

The greatest blow he had to suffer was his mother's death at forty-seven of cancer of the uterus in 1921. He swore he would recompense her death with his own glory: 'I swore to snatch my mother from death and destiny with the swords of light that some day would savagely gleam around my glorious name!'[18]

3

Madrid and La Residencia, 1922–26

Dalí's father enrolled him at the San Fernando Royal Academy of
Fine Arts, whose entrance exam Dalí sat in 1922. Right away he
proved himself to be Dalí by refusing to conform to the dimensions
of drawing he was supposed to submit: his drawing was far smaller,
but he was accepted all the same.

More important, in the long run, was his stay in the Residencia
de Estudiantes, on the outskirts of Madrid. It was run by the
delightfully young (and oddly named) Alberto Jiménez Fraud,
twenty-six years old, who had a liberal point of view and had
observed the tutorial system of Oxford and Cambridge. All sorts
of brilliant lecturers arrived there to perform, among them Wanda
Landowska, Francis Poulenc, Maurice Ravel, Igor Stravinsky, and
to speak, including H. G. Wells, Albert Einstein, Paul Valéry, José
Ortega y Gasset, Max Jacob, and most important for Dalí, Eugenio
d'Ors, the great expert on Baroque painting and writing who was
to defend him consistently during his career.

In the Residencia he met José (Pepín) Bello Lasierra, with
whom his correspondence was to yield much information on the
ongoing business of Dalí-ism. Bello found Dalí remarkably shy:
'He was a person sick with timidity, he was timidity itself.'[1] He
often blushed, and this blush must have had something to do
with its opposite, his quite extraordinary bluster. Bello found
he looked also like Buster Keaton, one of his heroes. Bello was
a great friend of Luis Buñuel, from Calonda in Aragón, and was

very good-looking, as well as an athletic freak. 'Tarquin the Proud', Buñuel was called, and this pride is certainly at the forefront in a great deal of his writing, especially in his memoir *Mon dernier soupir*. Buñuel was one of those Spanish intellectuals given to the long tradition of *tertulias*, or conversational groups, meeting usually in the cafés of Madrid, like the 'Pombo' which met on Saturday nights. He was a part of the *Ultraista* movement, begun in 1919, and including Jorge Luis Borges, Ramón Gómez de la Serna and Guillermo de Torre. They were closely related to the French writers and painters like Apollinaire, Cocteau, the Spaniards Juan Gris and Picasso, the Russian Sergei Diaghilev, the Italian Marinetti and the Chilean Huidobro. Everything was in a buzz in Madrid, as in Paris. And in spite of his timidity, Dalí made himself part of this buzz. But, said the always arrogant Dalí, 'my new friends couldn't give me anything since I had already twice and three times what they had.'[2]

In 1922 it was not only Madrid that buzzed. André Breton, about to be the head of the Surrealist movement in Paris and elsewhere, gave a celebrated lecture at the Ateneu in Barcelona, 'Aspects of the modern evolution and what participates in it'. Cubism, Futurism and Dada were all, he said, leading to a new and general movement (that was to become, two years later, 'Surrealism'). This lecture coincided with the exhibition of Francis Picabia at the Dalmau gallery, which was to be so crucial an institution for Dalí. These were machine paintings, and non-representational – an important term. Paris was to be the place of convergence of these currents into the new movement.

Besides Buñuel, there was also the poetic firebrand Federico García Lorca, the gregarious and stunning talker, pianist, story-teller and homosexual, who was to develop a true passion for the painter. He returned to the 'Resi' in 1923 and instantly became a great friend of Dalí. Despite Lorca's 'eminently religious spirit'[3] and Dalí's anti-religious point of view, their influence on each

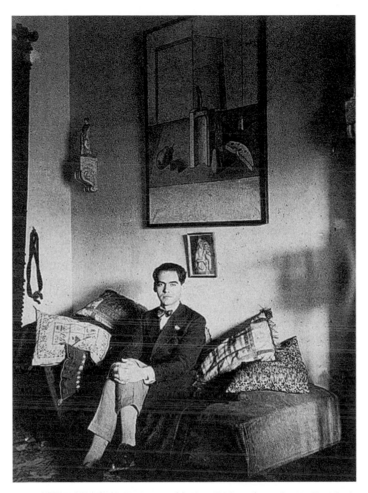

Lorca sitting under Dalí's oil painting of 1924, *Still-life: Syphon with a Small Bottle of Rum*.

other was without peer. It was, said Dalí, the personality of Lorca that so impressed him. There it was, real, present and overcoming: 'the poetic phenomenon in its entirety and "in the raw" presented itself before me suddenly in flesh and bone,

confused, blood-red, viscous and sublime, quivering with a thousand fires of darkness and of subterranean biology, like all matter endowed with the originality of its own form . . .'[4] When, on some days, they would all be walking to the café, and he knew very well that Lorca 'would shine like a mad and fiery diamond', he would set off running, absenting himself for three days.[5] 'The personality of Federico García Lorca made a great impression on me', he said.

> And when I felt the incendiary and communicative fire of the great Federico mount in those disheveled and crazed flames, I tried to calm them down with the branch of olive of my premature age of the anti-Faust even while I was already preparing the grills of my transcendental prosaism with which, when the time came, and when from Lorca's initial fire there would only remain the embers, I would come to toast on them the mushrooms and the cutlets and the sardines of my own thought, which I knew was already destined to be served one day, just cooked to the right stage, so as to be served very hot on a proper tablecloth of the table of the book you are reading right now so as to quiet down, for a hundred years, the spiritual, imaginative, moral and ideological famine of our epoch.[6]

Still at the Residencia, an event about not conversation but royalty was to occur. On 3 March 1923, King Alfonso XIII visited the Special School where Dalí was studying and the painter seriously considered setting off a bomb. If the plot didn't actually work, a less visible gesture did: instead of sitting in the armchair brought for him, the King insisted on sitting on the floor and, according to Dalí's account in the *Secret Life*, did a remarkable thing. He flicked the butt of his cigarette with a curve into a spittoon more than two metres away, to the admiring outburst of all the onlookers . . . And,

said Dalí, the King looked at me, I bowed, and suddenly saw a 'quiver of emotion pass across his famous Bourbon lower lip. There could be no doubt that we recognized each other!'[7] To what extent this is true, who knows. But the important thing is the recognition of genius by royalty. Being Dalí, all that wasn't enough. He decided, after the fact, to cause a ruckus, and so went to the sculpture room and opened a water tap all the way over a sack of plaster to flood the entire main stairway . . .

Other occurrences of those years mattered greatly to Dalí. The students voiced their opinion about the election of a professor for the special school – Dalí, accused of fomenting a rebellion with the students, was sent down for a year. He kept in touch, however, with his art teacher, Juan Nuñez, and that was the important thing.

He was thought of as trouble, and indeed he was just that. In 1926 for example, Dalí was supposed to pass an oral exam, choosing at random the topic from a drum containing balls with topics written on them. Dalí refused to touch the drum, saying that no one was fit to judge him: thus he was of course expelled.

The Residencia had a good library. The publishing house Biblioteca Nueva was devoted to bringing out crucial works such as the writings of Freud (whose *Interpretation of Dreams* was clearly of great importance to Dalí), and of Lautréamont (*Les Chants de Maldoror* of 1869, much admired by the Nicaraguan Rubén Darío, translated by Ramón Gómez de la Serna's brother, Julio, and prefaced, enthusiastically, by Ramón). As Dalí put it in the *Secret Life*, "The shadow of Maldoror was then hovering over my life, and it was just at this period that . . . another shadow, that of Federico García Lorca, came and darkened the virginal originality of my spirit and my flesh.'[8]

And in 1925 Lorca went with Dalí to Cadaqués during Holy Week, to stay at Es Llaner. They spent time with Lídia Noguer, thought of as a witch (who was impassioned with the critic Eugenio

d'Ors until her death) and they discussed Lorca's play *Mariana Pineda*, which he read aloud and for which Dalí would eventually make the sets. They visited the rock formations at Cape Creus and the Greek and Roman ruins at Empúries.

In the meantime Louis Aragon had been speaking on Surrealism at the Residencia on 18 April 1925. At the same time, in Madrid, a new association was formed: the Sociedad Ibérica de Artistas . . . They advocated plasticity, weight, volume, clarity –

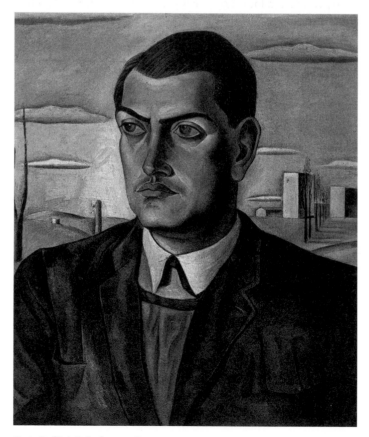

Portrait of Luis Buñuel, 1924, oil on canvas.

paintings did not mean, they just *were*. Dalí showed many paintings in their exhibition, including *Bather, Portrait of Luis Buñuel*, and one of the many portraits of his sister Anna Maria: *Seated Girl Seen from Behind*, all from 1924. He showed as well the interesting Cubist *Still-life: Syphon with a Small Bottle of Rum*.

Lorca hoped to have the painter visit his home in Granada. But Dalí was otherwise preoccupied. The gallery owner Josep Dalmau had invited him to have a one-man exhibition in the autumn, from 14–27 November, for which Dalí was busily preparing now that he was not returning to Madrid for the 1925–6 school year. The show was a triumph, and Dalí's future success was assured. His father, always a problem, would have preferred him to continue his schooling, pointing this out in writing the preface for a book of the positive reviews: 'I continue to believe that art should not be a means of earning a livelihood, that it should be solely a relaxation for the spirit to which one may devote oneself when the leisure moments of one's manner of life allow one to do so.'[9] Nevertheless, at Buñuel's urging, Dalí was preparing to leave for Paris to work with him on a film.

Dalmau had written him letters of recommendation for Max Jacob and for Breton, and finally Dalí left for Paris where his first visit, even before one to the Louvre, was to see Picasso. When he pointed out the sequence of planned visits, Picasso (not exactly devoid of arrogance either) answered that indeed Dalí had done the right thing to come to see him first: the painters had quite a share of self-assurance between them. In Paris the group of Spanish artists frequented the Montparnasse cafés Le Sélect and Le Dôme, to which Buñuel took him.

4

St Sebastian: Dalí and Lorca, 1926–28

I consider you the only true genius in the world.
Salvador Dalí to Federico García Lorca[1]

One of the most interesting writings of the poet and playwright
Federico García Lorca is his carefully constructed and famous 'Ode
to Salvador Dalí', which praises the exactitude of his painting and
imagination, and his unsentimental attitude:

> Oh, Salvador Dalí with your olive-colored voice!
> I say what your persons and your paintings tell me.
> . . .
> On taking your palette, with its bullet hole in one wing,
> you ask for the light that animates the top of the olive.
> The broad light of Minerva, the constructor of scaffolds
> where there's no room for dreams or their inexact flora.
>
> You ask for the ancient light that lodges in the brain
> without descending to the mouth or heart.
> The light feared by Bacchus's impassioned vines
> and the uncontrolled strength of the curved water.[2]

Much has been written about the involvement of the two artists,
generally based on some testimonies and Dalí's letters to Lorca; his
letters to Dalí have been mostly lost. To some extent Dalí's constant
fear of being homosexual played on the mutual attraction between
himself and Lorca. Lorca visited Dalí in Figueres twice, and accord-
ing to Dalí's accounts, was overwhelmingly in love with the painter.

The adoration was returned: Dalí was so overcome by Lorca's dazzle when he met him in 1923 that he feared even going to the café where they all gathered, and found himself wandering off in another direction. It was great emotion at first sight. They were enormously different: Lorca, says Christopher Maurer, was intensely a Catalan of Barcelona: 'There one finds the Mediterranean, the spirit, the adventure, the elevated dream of perfect love. There are palms, people from every country, surprising advertisements, gothic towers and the rich urban high tide created by typewriters. How I enjoy being there, with that air and that passion . . . I, who am a ferocious Catalanist, identified greatly with those people, fed up with Castile and so creative'.[3] Dalí, on the other hand, stood for clarity, not mystery, says Maurer. A serious break occurred when Lorca sent Dalí his *Cante jondo*, or deep songs, like gypsy ballads: folkloric, tragic, emotional, mysterious, they represented for Dalí the old order and the 'old poetry', against the newness and objectivity Dalí was aiming at.[4] For Lorca a part of any story disappears with time,[5] so the real narrative is made up of fragments and lacunae, is laden with emotion and mysterious feeling. Fragments, ruins and emotion made Dalí uneasy. For him, poems and paintings that tell anything at all lead to sentimentality (in other words, 'putrefaction'). He did not identify with the inner life, and was very much opposed to any sort of Bohemianism or romanticism. For him, art should remain on the surface of things, the very 'epidermis'.[6] According to his theory of 'Blessed Objectivity', 'What is deep is still an epidermis . . . Things have no other meaning besides their strict objectivity.'[7]

The 'putrefaction' or 'putrescent' element served as a code word for the three of them from the Residencia: Lorca, Dalí and Buñuel. It was used as the most extreme condemnation of a person, and was easily associated with the rotting carcasses in Dalí's work. Dalí writes to his friend Bello about the word: 'in the last analysis, putrefaction is SENTIMENT. Therefore it is something inseparable

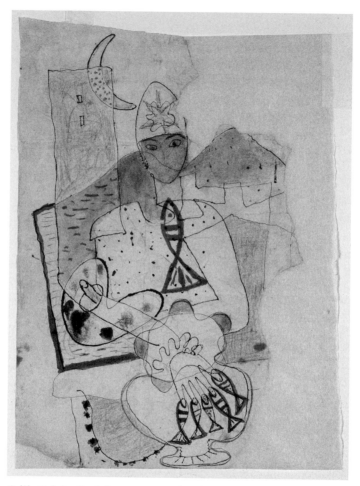

Dalí by Federico García Lorca, 1926, mixed media on paper.

from human nature. As long as there is an atmosphere around the earth, there is putrefaction.'[8] This was the opposite side of St Sebastian's magnifying glass, because of the 'exquisite absence of spirit and naturalness.' Haim Finkelstein explains further: '*putre-factos* designates philistines and conformists, especially in the arts

. . . all that was decrepit, dead and anachronistic in people and objects'. On *putrefactos*, that useful term, he quotes José Moreno Villa: 'a mind that is punctilious and peevish, hollow, full of commonplaces, of routine and idiotic prudence.'[9] All of this sounds, to be sure, like the very opposite strain of any Dalí or Lorca creation.

Now Buñuel, jealous of the relationship between painter and poet, would try to break it up, to some extent unsuccessfully. As he wrote to Lorca in September 1927: 'I thought that the boyfriend [Dalí] was putrescent, but now I see that the other is even worse. It's his awful aestheticism that has distanced him from us. His extreme narcissism.'[10] The jealousy of Buñuel is a whole story unto itself, given his wilful eradication of Dalí's name from many of the records of the films they did together. What remains as an inalterable and significant testimony to that intense relationship is precisely the literary and visual record, all focused on the legend of St Sebastian.

It all gets tied together in the legend: images and emotion, writing, painting, and suffering, all of it intense. The arrows aimed at and piercing the saint are often taken as phallic. So the sadomasochistic side of the figuring of the legend plays heavily in the fascination of both artists with the saint, homosexuality incarnate. Sebastian, pierced by and perhaps delighted by the arrows, is a perfect gay icon, as described by Richard Kaye in his article on Oscar Wilde.[11] Sebastian, of course, had to keep his Christian belief hidden: but he was found out, and the emperor Diocletian ordered arrows to be aimed at him.[12] And St Sebastian is not only the patron saint of Cadaqués, says Dalí, but the saintly personification of 'St Objectivity, who now goes by the name of St Sebastian'.[13]

Writing to Dalí in August of 1927, Lorca describes his feeling about those instruments of torture (and, here, of love), those arrows of steel: 'you see them fastened in him – fixed, stout, short arrows *which never grow rusty* – and I see them as *long* ones, at the very moment they have wounded him . . . Your St Sebastian is

made of marble, the opposite of mine, who is continually dying . . . his serenity in the midst of his misfortunes. Misfortune has always been Baroque.' He is, says Lorca, continually a victor in his suffering: how elegant! 'He is resigned but triumphant . . . filled with elegance and diffidence.' Lorca pictures this tortured and triumphant model dressed in shades of grey, 'like a steady, faithful oarsman oblivious to the avenues of the city'. And with all this in mind, in Easter Week of 1925, Lorca visits Dalí on the Costa Brava.[14]

So the often-told story (by Dalí in particular), about Lorca's trying to seduce him, is always associated with the Saint Sebastian figure. Dalí 'claimed he never had complete anal intercourse with Federico, because "it hurt too much".'[15] It is interesting that the Argentine translation of Bosquet's book *Dalí desnudado* omits that phrase. Christopher Maurer quotes Dalí: 'Deep down I said to myself that he was a very great poet and that I owed him a bit of the Divine Dalí's ar . . . He ended up by using a girl, and she replaced me in the sacrifice.'[16] The girl was said to be Margarita Manso, also a student at the School. Dalí often referred to Saint Sebastian when thinking of Lorca: 'Saint Sebastian I remember you . . . and sometimes I think he is you.' Lorca, he said, 'was in love with me. He tried twice to . . . me. I could not yield. Besides, it hurt. And thus the thing never took place. But I felt extremely flattered from the point of view of prestige.'[17]

Lorca is everywhere in Dalí's paintings, in the *Composition with Three Figures*, where his shattered bust lies next to the naked sailor with broken lance in his hand, in the decapitated statue in *Fish and Balcony* of 1926. In the fifteenth issue of *Amic de les Arts*, Dalí printed a drawing of Lorca with his hands crossed in front of his body, like the photo Lorca had sent him The painting *Atmospheric Skull Sodomizing a Grand Piano*, says one critic (Santos Torrella), represents Lorca's attempts to seduce Dalí. So, said Dalí to Lorca: 'You are a Christian whirlwind and you need my paganism.' He spoke of Lorca's 'eminently religious (erotic) spirit and my own strain of

religiosity'.[18] Lorca would go to Mass, loving its 'aroma of ancient pomp', and Dalí, at the café, would say 'I'm more interested in this olive.'[19]

Even Lorca's devotion to the painter was at times couched in religious terms. He writes to Sebastià Gasch in January 1928 about 'Dalí, who is imponderably marvelous . . . He moves me. Dalí fills me with the same pure emotion (and may the Lord forgive me!) as does the Christ child, abandoned in the manger at Bethlehem with the germ of the crucifixion pulsing under the hay of his cradle.'[20]

5

Dalí, Lorca and Catalunya, 1925–36

To My Beloved
If I didn't give you a sign
of my love and friendship
in truth, my love,
I'd hardly seem attentive.
Have the goodness, therefore,
to accept my offer:
soul, life and heart.
With an unequalled affection
love wide and without end,
I only feel happy
when I can be by your side.[1]

Lorca's view of painting, in his 'Sketch of the New Painting', is fully worth reading from the point of view of his admiration of Dalí: 'It is our glory as Spaniards to have produced the three great revolutionary painters in the world today. The father of all living painters is the Andalusian Pablo Picasso. The man who has created the theology and academy, Juan Gris, is from Madrid. And the divine poet and painter Joan Miró is a son of Catalunya.'[2] And his comments about the Italian (though Greek-born) 'metaphysical' painter Giorgio de Chirico resound when we see how greatly Dalí was influenced by him. Lorca: 'I believe that Chirico produced a new emotion of uncanniness, of solitude, of terror with his paintings. Jean Cocteau, the delightful French poet has said: "Chirico or the scene of the crime. Chirico at the hour of the train." Sure enough, his paintings have that anguish. Paintings with a strange, mortal air.'[3]

It is indicative of the closeness between Dalí and Lorca that some of Dalí's richest writings on his own painting are addressed to the poet. At the beginning of August 1925 Dalí explains to Lorca how he loves to paint without shoes, because 'I like to feel the earth very close to my feet.'[4] And then, about painting cold waves like the ones in the sea, 'Tomorrow I'll paint seven more. I feel calm because I have painted them *well* and every day the sea looks more like the one I am painting.' And again, 'I'm working on paintings that make me die for joy, I'm creating in a purely natural way, without the slightest artistic worry, and finding things that move me deeply, and trying to paint honestly, that is, *exactly*.'[5] And in December 1927: 'I feel a great love for grass, thorns in the palm of the hand, ears red against the sun, and the little feathers of bottles. Not only does all this delight me, but also the grapevine and the donkeys that crowd the sky.'[6]

For each other, Dalí and Lorca were interchangeably St Sebastian, who represented them and their relationship. And they drew together, literally as well as figuratively, during the summer of 1927: see *The Bather*, with its sketch of the sun, the mountains, the beach. The drama on which they worked together around the same time, *Mariana Pineda*, was not particularly successful, despite Dalí designing the sets. At this point he was writing his 'St Sebastian' prose piece, which he dedicated to Lorca. It develops aspects of irony, which for Dalí is equivalent to nakedness, and is exemplified by a Cadaqués fisherman who admires one of the Divine's paintings and says it is better than the sea, 'because one can count the waves'.[7] This figure of the saint shows, in all its double glory, 'the patience and exquisite death-throes' of Sebastian – the ultimate elegance, to be sure.

As well as elegance, patience and suffering, the important characteristic of this Holy Objectivity (the opposite of vagueness), is the clarity of detail, the sharpness of its outline – in this resides the sensuality of St Sebastian, wherever he occurs: in the art and in

the texts. Associated with this suffering figure – the intensity of the suffering exacerbated by the breeze always blowing from the sea – is a starfish bleeding (reminiscent of Robert Desnos's starfish of the same epoch, and Desnos's collaboration with Man Ray in the short film *L'Etoile de mer*). The landscape and the objects in the painting are distinct in outline:

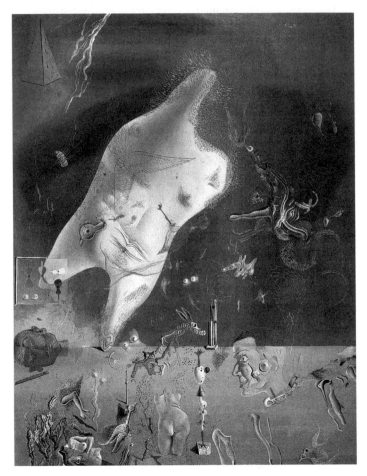

Little Ashes, 1927–8, oil on panel, originally titled *Birth of Venus*.

On the sand covered with shells and mica, precise instruments belonging to an unknown physics projected their explicative shadows, and offered their crystals and aluminiums to the disinfected light. A few letters drawn by Giorgio Morandi indicated *Distilled Gadgets*.[8]

The outlines of Dalí's painting *Distilled Gadgets* clarify the perspective, accentuated by a reference to the bottles and still-lifes of Morandi with their stark simplicity. De Chirico's cast shadows, Tanguy's vast spaces,[9] and Buster Keaton's 'pure poetry' in his unsmiling persona mingle here. In this quite extraordinary construction, we see a glass case full of shoes (copied from the one in the Grand Hotel, where Dalí stayed in August 1939, in Font-Romeu in the French Pyrenees), and also a row of tailors' dummies, reminiscent of the procession of Surrealist mannequins for the Surrealist Exhibition. For a background, there are Douanier Rousseau's naive backdrops. All this is seen through St Sebastian's magnifying glass, a bewildering vision.

The manifesto to which all this elaboration of unsentimental clarity gives birth is the *Anti-Art Manifesto*, a frontal attack on the Catalan art scene by Sebastià Gasch, Lluís Montanyà and Dalí. The last-named was beginning his *Birth of Venus* (later retitled *Little Ashes*) and the famous (alas, lost) *Honey is Sweeter than Blood* (for which Lorca seems to have proposed the title *The Wood of Gadgets*).[10] Discussing the departure from his previous painting in this work, Dalí explained to the editor of an art review that it was inaugurating 'a new orbit, equidistant between Cubism and Surrealism on the one hand and a primitive art such as Brueghel's on the other'.[11] Dawn Adès points out how close this painting is to the 'mental beaches' of Yves Tanguy, with their great spaces, populated with small figures in clear outlines.[12]

Lorca, on his way back to Granada, where he always wanted Dalí to visit, speaks of this canvas and Dalí's 'pictorial blood' –

he realizes, he writes, how very much he will miss Dalí by leaving Cadaqués.[13] Had he recently tried again to seduce the painter? The following passage in a letter he sent at the end of August might seem to corroborate that view:

> I behaved towards you like an indecent ass, you who are the best thing I've got. With every minute I see it more clearly and I'm dreadfully sorry. But it only increases my affection for you and my identification with your ideas and your human integrity.[14]

Gibson advances the idea that 'honey is sweeter than blood' is the equivalent of 'masturbation is sweeter than fucking'.[15] The clue he adduces is in *The Secret Life*, where Dalí is recounting a scene of masturbation: 'Once more I wrenched from my body that familiar solitary pleasure, sweeter than honey, while biting into the corner of my pillow lighted by a moonbeam, sinking my teeth into it till they cut through the saliva-drenched fabric.'[16] And one of the paintings of this period seems to advance this idea: *Gadget and Hand*, in which there appears a red hand with veins, surrounded by a rotting donkey nibbling at a fish, a female bather and some breasts flying about, to say nothing of a headless female torso. The red hand could be interpreted as shame of masturbation or 'self-abuse', as it was called in this period.

Lorca's death was in a sense prefigured by Dalí in *Honey is Sweeter than Blood*, in which Lorca is observed by Dalí, who predicts his death. And after his murder at the hands of the Guardia Civil, his absence far from stopped his representations by his beloved Dalí. He appears, clearly, in the *Hallucinogenic Toreador*, done in 1938, during the Spanish Civil War. After his death, his bust became a fruit bowl on the beach . . . *Appearance of a Head with Fruit Bowl on the Beach*, or then *Invisible Afghan with the Appearance on the Beach of the Face of García Lorca*. Dalí will always be haunted by Lorca, to the end of his life. This was, no doubt, the major

relationship early, and the one he most remembered, late. If Dalí's ambitious self was obsessed by Picasso, his emotional self was totally absorbed by Lorca.

6

Miró, Dalí and Surrealism, 1928

Upon his yearly return from Paris to the family farm at Montroig, west of Tarragona, the generous Joan Miró suggested that his dealer Pierre Loeb should see some of Dalí's work, as one of the young Catalan painters. He wrote this to Sebastià Gasch, who was always ready to help Dalí. (Another useful friend of this period was Josep Vincenç Foix, a writer of the Barcelona avant-garde connected with the Barcelona paper *La Publicitat*. At this point, all publicity was good publicity; and in fact, that was to be true throughout Dalí's life. He loved publicity, as was always crystal clear.)

The point about Pierre Loeb's coming to see Dalí's work right at home was that he would not be named, so Dalí would not suspect anything was up. He didn't, but was delighted to show his paintings which seemed to him representative of his production of the moment: these were *Honey is Sweeter than Blood* and *Gadget and Hand*. The visit was a success, and Dalí wrote to Lorca what a 'creature of enormous Purity' Miró was, and how that term meant for him the sexual elements common in Miró's work.[1] From then on, he abounded in praise for the painter from Mont-roig in his articles for *L'Amic de les Arts*, in which he frequently stated his opposition to Surrealism and to 'artistic' painting (painting appealing to those who know, whereas his were intended to appeal to the unconscious, being therefore available to those with 'simple hearts and minds'). But clearly, his referring so often to Surrealism was to be indicative of its relevance for him.

Miró had not ceased his working for Dalí's reputation in Paris, urging Loeb to sign him up and writing to Dalí that Loeb had given some photos of Dalí's work to Christian Zervos at *Cahiers d'Art*. Since Paul Rosenberg, who had been in touch with Dalí after his Dalmau exhibition, also wrote him encouragingly, Dalí was feeling well set up in Paris. At Miró's suggestion Dalí purchased a dinner jacket and prepared to go out in company.

But he didn't stop asking for payment for the sets for Lorca's play *Mariana Pineda*. To the delight of the envious Buñuel, that play appeared to have been a failure – more of one than it actually was. What Buñuel seems to have resented above all, along with the friendship of Lorca and Dalí, was the homosexual aura of the whole thing. He had his puritanical side, which sometimes comes to the fore in his autobiography, *Mon Dernier Soupir*.

Now, despite what Dalí had said against Surrealism before, he valued Breton's writing, especially the latter's preface to Hans Arp's exhibition at the Galerie Surréaliste in Paris and his essay 'Surrealism and Painting', which he commented on for *L'Amic de les Arts*, in 'The New Limits of Painting'. Dalí especially admired Breton's invective against the idea of 'paroles mendiantes' (words that beg, as for a table to be eaten from or leaned on, or mountain to be climbed or looked at), that is, against the *use* of words as opposed to the real *autonomy* of vocabulary. Words were to stand for themselves, to be the inner landscapes of the marvellous and all that the best Surrealism stands for. 'Reality and Surreality', Dalí titles his thinking and writing.

When he met the great Surrealist poet Robert Desnos at the Coupole, they spent time together, but Dalí was bored by Desnos's inexhaustible lyric tongue, and his raving on and on about Robespierre. They were not fated to be friends, no more than Dalí and Breton. Picasso was the only one who aroused Dalí's enthusiasm and envy, both of them lifelong. Among the poets, it was Paul Éluard whom Dalí admired, finding him to be the equal of his

adored Lorca, so Dalí's ending up with Gala Éluard, Paul's wife before she became his, makes a certain sense, and has a certain irony.

In March 1928 the *Anti-Art Manifesto* appeared, printed on yellow broadsheets and thus called 'The Yellow Paper', occasioning a great deal of commentary all over Catalonia. To a certain extent, the advocacy of modernism (however it was then conceived: jazz, films, aeroplanes, etc.) over the stagnant pool of local colour prefigures the quarrel Dalí will have with Lorca over the old-timey feeling of Lorca's *Gypsy Ballads*, or his *Cante jondo*, traditional, provincial, and everything that Dalí wanted not to represent. (He writes to the poet that when he becomes fearless and eschews 'Rhyme – in short, art as understood by the pigs – you'll produce witty, horrifying, intense, poetic things such as no other poet ever could.'[2]) When, on 13 May, Dalí, Foix and Josep Carbonell (editor of *L'Amic de les Arts*) went to lecture at the Sitges Ateneu 'El Centaure' about recent trends in art and literature, Dalí recommended the razing of Barcelona's Gothic Quarter, the abolishing of the local dance, the *sardana*, and the timeworn patina of Catalan art such as it was being practised. Then, on 21 May, he spoke about the progress of painting from Cubism to Surrealism and its appeal to the unconscious. His thought, he alleged, was totally separate and independent from Surrealism, but nevertheless on the same wavelength.

In his article 'Photography, Pure Creation of the Mind', Dalí points out that, as opposed to the passive automatism of Surrealism, his idea of the uses of the unconscious by more objective means implies such techniques as those of film and photography. And in fact, says Dawn Adès,[3] such paintings as *Honey is Sweeter than Blood* and *Little Ashes* already demonstrate the manipulative possibilities of the camera, and the montages, superimpositions, fade-outs and dissolves of film. 'To look', says Dalí, 'is to invent'. That is clearly more active than the *état d'attente* or the

Photographs by Regnard from J.-M. Charcot, *Iconographie photographique de la Salpetrière*, vol. II (1878), which Dalí reproduced.

state of expectancy of Surrealism. In a letter of September 1928 to García Lorca, Dalí relates the gypsy ballads of the poet to 'the norms of the old poetry . . .' and urges him to do 'things that are more fun and revolting and curly and poetic than any poet has ever done'. He continues about Surrealism, that it is 'only one means of Evasion. It is the Evasion itself that matters. I have manners in the margin of surrealism, but that is something living.'[4]

According to Adès, from early on, doublings of elements and repetitions had been part of the order of the day, and images such as floating breasts and flying fingers demonstrate Dalí's close attention to Freud. In his text the 'Liberation of fingers' in 1929, he had probably read Freud on the flying phallus, although he declared to a friend that he could not have. His obsessive dwelling on images such as those of his own erect finger sticking out of the hole in his palette (like the erect fingers pointing skyward in *Little Ashes*) is on a plane with the horrible image of Boiffard's *Big Toe* photograph pictured by Bataille. All the paintings and texts between the years 1927 and 1930 are related to such images.[5] In the texts of *Visible Woman*, so wonderfully illustrated on its cover by the piercing gaze of Gala, he contrasts the passivity of Surrealist automatism with the active chosen mode of paranoia.

Everywhere there are the conjunctions of opposites (as in the alchemical *conjunctio oppositorum*). In *Un Chien andalou*, as Adès points out, hard and soft, form and formlessness mingle, as, in the *Great Masturbator*, do flesh and stone, petal and hair, lava and the winding forms of Art Nouveau. In the texts of *Visible Woman* the double figurations of paranoia abound: modern-style architectural references and the systematic misreading of objects and new 'simulacra' – of which, says Dalí, the three great ones are excrement, blood and putrefaction.[6]

Desire and the horrible are, as we know, intertwined. Furthermore, the horrible, the horrendous, the nightmarish detail has its use. In the *Profanation of the Host*, the heads struggle to

emerge from the thicket, and in several paintings grasshoppers are attached to mouths. (Read 'locusts', as in the earlier explanation.) This is the repetition of the horrible that is the delight of unpleasure, as in the journal *Minotaure* of 1936.[7]

A further incident about the necessary subversive character of art serves to underline Dalí's point of view about the horrible and its uses. A painting he sent to the Barcelona Autumn Salon, *Dialogue on the Beach*, was rejected by Joan Maragall, and then accepted by the Dalmau Gallery, delighting the painter, for whom it was absolutely essential that his work have 'the subversive value of horrifying and traumatizing the public'. Later called *Unsatisfied Desires*, the painting shows a finger like a phallus, a penis and testicles, and an orifice like a vagina: a work deeply suggestive of masturbation, in short. Thrilled by the publicity, and by the opportunity to lecture on the subject, Dalí exhibited it at the Dalmau Gallery on 28 October, the day after the Salon closed.[8] Now this recalls, to the reader of Surrealism, the famous quarrel over Louis Aragon's enraged poem 'Front Rouge' (railing against the bourgeois mentality, demanding acts of violence against the social setup) for which he was condemned by the French judicial system. Breton leapt to his defence, because, he said, it was only a poem, implying that the aesthetic is separate from the political and the actual; but Aragon insisted on the real and topical nature of the work of art, engaged in the throes of actual life and politics. During the Autumn Salon, on 16 October 1928, Dalí lectured, praising Miró again for his 'purity' and Surrealism for its recognition of the 'real' and 'deep' elements in the human spirit, i.e. the unconscious.

More: Dalí's father, alarmed by the nature of the painting, wrote to Dalmau to find some way of resolving the situation. Dalmau suggested they cover the objectionable bits! (This would have delighted the fearful diplomats of the US government, who covered up the bare breasts of a statue in the UN, covered up Picasso's *Guernica* – not very inspiring for the idea of a 'preventive attack'

and on and on.) So Dalí gave in, in writing, and did not show the offending *Dialogue on the Beach*, substituting for it a less explicit *Male Figure and Female Figure on a Beach*.

Being 'true to the reality' of his inner life was now Dalí's explicit goal, along with obtaining 'international prestige'. Well, the latter he certainly did, increasingly. 'The aureole of my prestige', he called it.[9] He considered himself the only real Surrealist, and maintained that the others were a pale imitation of himself, and of his ideas, as they haunted 'the sterile terraces of Montparnasse' and he continued his revolutionary ideas of 'modern style' and his 'growing psychic anormality'.[10]

His own take on the 'fashion of surrealist objects' has left its mark, for example on the 2007 exhibition 'Surreal Things: Surrealism and Design' shown at the Victoria and Albert Museum in London. His definition is workable: 'The surrealist object is one that is absolutely useless from the practical and rational point of view, created wholly for the purpose of materializing in a fetishistic way, with the maximum of tangible reality, ideas and fantasies having a delirious character.'[11] Very Dalí, most of it. And his ideas, far-out or not (mostly far-out) were seminal for the future avant-garde. Take his immense affection for bread: its enigma was that it could stand up, you could put holes in it and inkwells in the holes, you could make very long loaves, of fifteen metres, you could put the loaf atop a mannequin and even tempt Picasso's dog to come and eat it, which he did. Take his hard-boiled egg table, which you could also eat.[12]

Dalí said he was obviously 'the most partisan, the most violent, the most imperialistic, the most delirious, the most fanatical of all'.[13] And in fact, 'I was surrealism.'[14] What else to say?

7

Buñuel and the Cinema, 1929

In Barcelona, Buñuel often attended the meetings of the literary circle *Pombo*, whose leader was Ramón Gómez de la Serna. He had wanted to film a series based on stories by Gómez de la Serna, but the latter never presented him with the screenplay. Thereupon Buñuel showed his idea to Dalí, who had written his own screenplay, which was enthusiastically received by Buñuel. In 1928 they worked on a script together in Figueres, which became *Un Chien andalou* (*An Andalusian Dog*), with no argument between them, as Buñuel wrote fifty years later, in *Mon Dernier Soupir* (*My Last Sigh*). The title 'Le Chien andalou' had originally been destined for a book of poems by Buñuel, but this never came to fruition, so it was transferred, with an indefinite article ('An'), to the film. Lorca was always convinced that the 'Andalusian dog' was himself, said Angel del Rio, a professor at Columbia University. And maybe so, since for Dalí and Buñuel the 'Andalusian dog' of the film was indeed he. Dalí and Buñuel accepted the first idea that came to them, and the first images, sometimes elaborating on them: thus, from one donkey on top of the grand piano to two donkeys, both rotting. 'Fantastic!'[1]

Among the 'fantastic' images presented by Dalí in *Un Chien andalou* was the world famous shot of the eyeball sliced in two by the cloud. Not only had he seen such a cloud slicing the moon in two, he had written, in 1926, a piece about a razor menacing a girl's eye; and such an image also occurs in Mantegna's *Death of the*

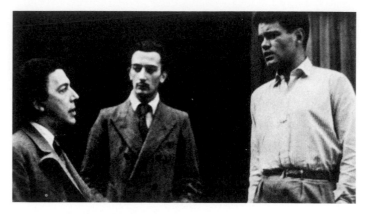

André Breton, Dalí and René Crevel, *c.* 1934.

Virgin, admired by all three of the comrades – Lorca, Dalí and
Buñuel – and then in José Moreno Villa's recounting, at the
Residencia, a dream in which he cut his eye while shaving, with
a razor.[2] Blinding is of course the classic example of castration in
Freudian imagery, and the highly disturbing image has caused a
great deal of commentary, from this and many other points of
view.[3] Later, Buñuel was to claim sole authorship of this image and
others: the ants coming from the hole in the hand, the rotting
donkeys, and so on.

Buñuel and Dalí had other common ground: for example, an
admiration for the poetry of Benjamin Péret the Surrealist. Buñuel
wrote, in his memoirs: 'Benjamin Péret was for me the Surrealist
poet par excellence: total freedom, a limpid inspiration, like a clear
fountain . . . In 1929, Dalí and I used to read aloud some of the
poems from *Le Grand Jeu* and sometimes we ended up on the floor
killing ourselves laughing.'[4] And Dalí would speak to journalists
about this being the first 'surrealist transposition' in the cinema,
akin to the automatic experiments of Péret.

Buñuel was invited to meet the Surrealist group at the Cyrano,
near Breton's apartment. Everyone was there among the Surrealists

– Max Ernst, André Breton, Paul Éluard, Tristan Tzara, Yves Tanguy, Hans Arp, René Magritte. Dalí was welcomed gladly in the Surrealist group. At this point he was painting *The First Days of Spring* (the Surrealist poet Robert Desnos waxed enthusiastically that he would like to have bought it, had he had the resources) and also *The Great Masturbator*. This was in the summer of 1929, a grand summer.

Un Chien andalou was shown at the Studio des Ursulines on 6 June 1929: Robert Desnos, an avid moviegoer and writer of essays on film, raved about it:

> I do not know any film which works so directly on the spectator, any film which is made so specifically for him, which engages him in conversation, in intimate rapport. But whether it's the eye sliced by a razor, and whose crystalline liquid trickles viscously, or the assemblage of Spanish priests and grand pianos bearing its load of dead donkeys, there is nothing in it that does not partake of humour and poetry, intimately linked.[5]

Some critics praised the intensely Spanish quality of the film, its unrefined nature, far more violent than the French. The Viscomte de Noailles, Charles, and his wife, Marie-Laure, rich patrons of the arts, loved the film and showed it in their private cinema to all sorts of people who could be useful to Buñuel. And on top of that the couple then commissioned another film from the two-person team (for Buñuel at this point was thinking of them as a team, whereas later he was to omit Dalí's name from the credits). Buñuel suggested they could work together that summer in August on the next film.

In the meantime Dalí was haunted by recurring images. We see a rabbit's head, which shares its eyes with a brightly coloured parrot, enfolded by a fish, to whose mouth a grasshopper clings (Dalí's nightmare image, originally a locust); while nearby stands a chalice

and the wafer of the host (*hostie*). An older figure, presumably representing the father, is staring hard at something, holding a bloody cloth covering some instrument or other. Everything is violently oppressive here: eyes and staring violence and cover-up, shame and sexuality. All these delights appear in one of Dalí's most remarkable paintings, as they issue from the head of the Great Masturbator in *The Lugubrious Game*, whose title, said Dalí, was given by Paul Éluard. This is the painting portraying the trousers soiled by excrement (like Dalí's father's exclamation 'I've crapped!') that so haunted Dalí.

Georges Bataille had wanted to reproduce this painting in an issue of *Documents*, but Dalí refused, so Bataille just made a sketch of it, and had to point out to Breton that it was just a simulacrum. Breton, something of a puritan, attacked the far more subversive Bataille for his essay 'The Language of Flowers', in which Bataille had spoken of the 'hairy sexual organs' in the centre of flowers, whereas Breton claimed that the 'rose, stripped of its petals, remains the rose'.[6] On this divergence of attitude much hinged. In any case, the issue of excrement is a delicate one. It was on the subject of *The Lugubrious Game* that Gala asked Dalí if he was 'coprophagic' and he answered that he was not, despite the excrement in this painting.[7] Those who recall the ludicrous reaction of New York's former mayor, Rudolph Giuliani, against the excrement in the painting of the Madonna by Chris Ofili may be specially interested in this interchange.

Early in August 1929, Éluard, Gala (whose full name was Helena Diakanoff Devulina) and their daughter Cécile arrived in Cadaqués. The complications of this couple were celebrated: he enjoyed showing pictures of his wife naked, and apparently had no objection to sharing her, as indeed he shared himself with many women. The beach at Es Llaner made a perfect background for Gala's attraction for Dalí, which was immense and intense. She, for him, was the real-life incarnation of the character in Wilhelm

Jensen's debut novel *Gradiva* ('the girl splendid in walking', 1903). She had had a French governess and so conversed with Dalí in the French he preferred to use. In his imagination and writing, she will become a child he has seen before, and she will merge with his own genius in the years to come, as *GalaDalí*. Her passion for mystical and occult things, her need for sexual satisfaction and promiscuous living style with Éluard, her own style mixed with her kind of cruelty and mysteriousness – all this appealed to Dalí endlessly. Here is what he wrote in his manuscript of *La Vie secrète:* 'Ge 29 ans a Cadaques ge fai la cour a Gala / ge suis a pié nu . . . ge suis fou de boneur' ('I am 29 in Cadaques, I am making love with Gala / I am barefoot . . . I am mad with happiness.')[8] However, says the editor, he was really twenty-five but makes himself older, like the 'anti-Faust he is', or then he might have mixed it up with the year 1929. Gala, as much of a sensual eater as Salvador, writes about one of their meals: 'one of these little unpretentious country wines which make up one of the most delicate secrets of the Mediterranean, for they have this unique taste where you can savor the bitter and sentimental taste, of tears, mixed with a lot of unreality . . . We finished the meal very late, for the sun was already sinking.'[9] The editor points out how typically Dalínian is the twilight hour. She cuts out the 'coffee' they drank, from Dalí's original text. Too simple, that coffee, maybe too simple.

And Buñuel was watching. He claims, in *My Last Sigh,* that the change in Dalí was instant and permanent. As he had been jealous of the friendship of Lorca and Dalí, so now Gala became jealous of Buñuel's friendship with Dalí, her possession. Everything about Gala was violent, excessive, mad. Once she insisted that Dalí kill her, he says in his *Secret Life.* 'Ge veux que vous me fesiez crever!' ('I want you to kill me!')[10] as he puts it in his inimitable French, which comes into its own in the original version of his *La Vie secrète,* definitely not the one typed by Gala, which is translated into English as the *Secret Life.*[11] Dalí's painting, *The Accommodations*

Sometimes I Spit for Pleasure on the Portrait of my Mother, or The Sacred Heart, 1929, ink on canvas mounted on cardboard.

of Desire (1929), Dalí says, represents his sexual anxiety over Gala, as do many of his other paintings. Finkelstein says of this painting and its terrorizing images that the lion's head represents the father, William Tell – that is, the castrating agent – while the culprit is the

masturbating son. The pebbles, like frames facing the viewer, are instances of the unsettling form of unrelatedness, like collage.[12] But surely something about the way she provoked in him his anxiety must always have enabled his creation – in any case, the new couple worked well, and Éluard left for a voyage, to escape the whole upsetting thing.

What of the others in this peculiar drama? Needless to say, Dalí's father was unenchanted with the change in his household. He changed his will, disinherited Salvador, and took to calling Gala, with whom Dalí now lived, 'la madame'.

Finally, in Paris, Dalí and Buñuel started to work on the new film, at first called *The Andalusian Beast*, to follow on from *An Andalusian Dog*, but later replaced by its current title, *L'Age d'or*. In this superbly Surrealist film about the struggle of society and sex, there are traces of Marie-Laure's ancestor, the Marquis de Sade. But the family drama continued, exacerbated to the extreme. For at an exhibition at the Goemans Gallery, along with many other paintings of Dalí's, was something called '*parfois je crache par Plaisir sur le portrait de ma Mère*' ('Sometimes I Spit for Pleasure on the Portrait of my Mother'). Dalí's father, furious about the work, had expelled him from his house, but let him use the family house in Cadaqués to work with Buñuel on the new film. Dalí, upon receiving a letter from his father that banished him 'irrevocably', wrote about the disinheritance, shaved off all his hair and buried it on the beach at Es Llaner. Then, before he left, he had Buñuel photograph him with a sea urchin (always his favourite food) on his bare head. Whatever this gesture might have meant, he then left for Paris, abandoning his possessions in the family apartment in Figueres. He didn't speak to his father again before five years of steady creation had elapsed.

Filmic Dalí

You might not have imagined that Salvador Dalí and Disney had much in common. Yet in 1946 the painter was making a short film with Walt Disney, *Destino*. The project was dropped, but with Disney's nephew, it was resurrected and redone in 2003. Briefly, a pair of turtles meet, their bodies form a ballerina, who dances through some deserts, whose head becomes a baseball then detached, rolling down her arm, so she can lob it off elegantly. Subtle stuff.

It's all always about show: but that is what the public seems to buy into. In 1965 Dalí directed a film about a sculpture being carried along – shouting how it should be done, where the camera should be directed, how it should catch him, then succumbs to a fit of anger, and walks away, after stepping on and crunching a piece of the statue. This mockery of a heroic gesture of inimitable anger is where the film was leading. Dalí is always vectoring himself toward whatever gesture or carefully planned accident is most dramatic. His moustache – surely his most recognizable attribute – can curl up, as in the ad for Lanvin chocolates. Or then it can compose a dollar sign . . . In fact, Dalí had nothing against André Breton's pejorative appellation, 'AVIDA DOLLARS', because the avarice, clearly stated, makes part of the myth. And he was about myths.

One of the most pertinent pieces on Dalí's film production is that of J. G. Ballard, writing in the *Guardian* in May 2007. The

piece appeared in tandem with the Dalí exhibition at Tate Modern, which emphasized his film work, as did the parallel exhibition in Los Angeles. According to Ballard, who says he appreciates Dalí more than Picasso, Dalí 'was the last of the great cultural outlaws, and probably the last genius to visit our cheap and gaudy planet'. He upset all the values of the cultural establishment 'by posing as their worst nightmare: a genius and show-off greedy for money'. Nobody could be sure, with Dalí's Surrealist act, if it was or was not fake. His preposterous way of speaking English, his 'gigolo manner', occupied a 'bizarre space between American *Vogue* and a seaside freak show'.[1]

As for his films, Ballard declares there are really only two, those two Surrealist classics done with Buñuel: *Un Chien andalou* of 1929, with its ants coming out of the man's palm and its iconic slicing of the heroine's eyeball, and the longer *L'Age d'or* of 1930, more upsetting still to the bourgeois sensibility – given its attack on a blind man and its piano dragged out with two donkeys – and to the Catholic establishment, given the final crucifix burdened with several scalps . . . Just as Dalí's irreverent humour had such an effect on the deadpan performers Gilbert and George, on Damien Hirst, Tracey Emin, the Chapman brothers, and other 'Young British Artists', to say nothing of his effect on Andy Warhol, Jeff Koons and Matthew Barney, in their performance of the artistic persona, it seems indisputable that this crucifixion scene should have had a tremendous impact on *Monty Python's Life of Brian*, which ends with a collective song of happiness on the various crosses with their victims lustily belting out how we should 'look on the bright side of life'. Just animal high spirits: in fact, there is a lot of animal frenzy in Dalí's films . . . ants crawling over a palm, donkeys in the piano room, giraffes set on fire, and the rhinoceros in the film Dalí was doing with Robert Descharnes: *The Lacemaker and the Rhinoceros.*

Like so many of Dalí's projects, many film ideas just didn't come off. One of the more interesting is the 1982 project for a film

to be called *Enigma Dalí*, with the director Luis Revenga. It was being filmed in the dining room at Púbol, and Dalí was singing a popular song called 'La filla del marxant', when he fell over in a sort of ecstatic trance. This had been a film to send to Buñuel, when Dalí was hoping they could make another film together: too late, said Buñuel . . .

The film called Dalí's *Soft Self-Portrait*, narrated by Orson Welles, which features the birth of Gala and Dalí from an egg, with much twirling of the moustache, with its notion of 'soft' playing back on those soft watches and the *Soft Self-Portrait with Fried Bacon* of 1941 and an echo of a 'shill' (a person attracting others to a loaded card game), is about as silly as Disney's *Silly Symphonies*, which Dalí much admired. Welles, with his usual wit, describes the painter as 'not only a wizard in command of real mysteries, but a charlatan'.

A little after Ballard, in June 2007, Laura Cumming writes on 'Dalí and Film', also for the Tate exhibition, also in the *Guardian*, mentioning Dalí's frequent 'jump-cuts, focus-pulls, and discontinuities', and the 'queer hilarity of it all'. [2] About his dream sequence in Hitchcock's *Spellbound*, with its scissors, eyeballs and soft clocks, she points out that Hitchcock chose him precisely because he did not want the blurry focus we usually associate with dreams, and liked the hard-edged sharpness of outline in Dalí's work. Going along with this is Dalí's tendency to spell things out, as opposed to the suggestiveness we associate with other surrealizing creators.

In the fall, to accompany the Dalí *Film and Painting* exhibition at the Los Angeles County Museum of Art (LACMA), Richard Schickel reviewed the large book on *Dalí and Film*, edited by Matthew Gale, for the *Los Angeles Times*. Gale points out Dalí's 'hilarious subversion of genre clichés and behavioral politesse, all managed with deadpan aplomb' and Schickel supposes that the exhibition is an attempt to restore something of Dalí's reputation, so drastically in decline because of his 'clownish, indefatigable self-

promotion'.[3] He is surprised, as I was, that no one even mentioned George Orwell's essay on the painter and his incredibly detailed style of drawing, which would be more appropriate for illustrating scientific books. Schickel finds the exhibition, like the artist, to be entirely hollow at the centre. Since Dalí had no gift for narrative, it would have been impossible for him to break into the Hollywood scene as he had wanted to, and this lack doomed also any attempt to make avant-garde films: no plot. So yet again Dalí's art comes down to a gift for detail, not for the overall picture . . .

An interview with Sara Cochran, the curator of the LACMA show, titled 'Art Behind the Scenes', is available online.[4] Accompanied by a few images, it has, because of its oral nature, a clarity of exposition and unselfconscious performance which is not, to understate the case, always available in Dalí's own writings, nor in the gush often surrounding his paintings. Cochran emphasizes the split between the notion of Dalí as a mad genius and as a craftsman taking infinite care over every detail, for his painting he called 'handmade photographs'. Hyperrealism – or more than close 'realistic' detail – seemed to be very popular with the public. In large part, it is this dichotomy between one side of Dalí and the other that makes up his appeal, sometimes on the decline, sometimes on the rise, like his moustaches.

Paris, Surrealism and Gala, 1929–30

So Buñuel and Dalí officially entered the Surrealist group in 1929. Breton's Second Surrealist Manifesto and Dalí's *Accommodations of Desire* and *Illuminated Pleasures* appeared in the last issue of *La Révolution surréaliste* (before it became *Le Surréalisme au service de la Révolution* with a Marxist orientation, strongly Trotskyist), along with the screenplay of *Un Chien andalou*. The opening shot of the balcony and the razor-blade slicing the young woman's eye (it is said to have been the eye of a donkey) – like the palm of the hand with the ants crawling out of a hole, the donkeys on the pianos, and the death's head on the moth's back – all these striking images remain in the viewer's mind long after the film's narration.

Breton was later to recall how Dalí incarnated the Surrealist spirit in a way that he could not have, had he been involved in all the early struggles. Dalí created the frontispiece for the *Second Manifesto* at the end of the next June, and even made a scenario for a documentary to 'explain' Surrealism and automatic writing, with a clip from *Un Chien andalou*. The documentary itself was never made, but the scenario develops the idea of paranoia and its relation to imagery, all important for his eventual theorization of the Paranoiac method, essential to his art and thinking. Paranoia-criticism was to undermine the concept of Surrealist automatism, which seemed to Dalí far too passive. In this 'voluntary hallucination', Dali would stare at the canvas, forcing images to spring up. Dalí continues: 'Of a cubist picture one asks: What does that represent?

– Of a surrealist picture, one sees what it represents but one asks: what does that mean? Of a paranoiac picture one asks abundantly: What do I see? What does that represent? What does that mean?'[1]

Dalí's paintings and writings from 1927 to 1929 would all by themselves fill volumes of worthy discussion, and indeed they have. This is the summit of his creation, as most commentators see it, and I agree with them. Yet, in this tiny volume, I am taking only a very few of them as exemplifying the rest. These are *anni mirabili* by anyone's reckoning, both textually and visually. I will start with one combination, *The Great Masturbator* of 1929, of which we have both versions, poem and painting.

'The Great Masturbator'

Westward rose the principal edifice of the town
constructed of false red bricks
one could hear dimly the sounds of the town
despite the prevalent darkness . . .
it was still early evening
alongside the large flights of stairs made of agate where
fatigued by the daylight
the Great Masturbator
his immense nose leaning on the onyx-inlaid floor
his enormous eyelids closed . . .[2]

The head in the painting *The Great Masturbator* was inspired by a rock near Cape Creus, at Cullaró – visible in *The First Days of Spring*, an earlier painting – and appears accompanied by other figures familiar in paintings of this time: a lion, a locust, an arum lily, and a couple embracing. In the poem we see rotting mouths, a grasshopper clinging to them, a moustache 'lightly soiled with real shit' and a hand with ants emerging, as in *Un Chien andalou*. The last two lines quoted above refer to this giant head with eyes

closed and nose resting, as the great figure is tired.

With Gala, Dalí went in January to a hotel near Marseille (the Hôtel du Château at Carry-le-Rouet), where they stayed until March. The seaside was important to Dalí, and he was enchanted to hear from his mad friend Lídia, 'the witch' from Cadaqués, that she had a tiny shack in Port Lligat ('the tied-in harbour'), near Cadaqués, right at the foot of Cape Creus and its extraordinary rock formations, themselves so conducive to paranoiac visions. Marie-Laure and Charles de Noailles (who commissioned the screenplay of the continuation of *Un Chien andalou*) sent enough funds to cover the remaking of the 21-metre shack in exchange for a painting, and would have Dalí's *The Old Age of William Tell* as

Dalí photographed by Luis Buñuel, Cadaqués, 1929.

their payment. The photo that Buñuel had taken of Dalí with a sea urchin on his head had prefigured all the later recurrences of the legend in the painter's work.

As for the development of *L'Age d'or*, all sorts of scenic ideas were being sent by Dalí to Buñuel in Paris: the hero and heroine (if we can call them that) sucking each other's fingers, a fly-button undone, all sorts of double images, and a raft of 'tactile sensation', such as hot water dousing the fingers of the audience when they hear water going into a bidet, so that the audience would go mad, even 'beserk', a true culmination of participatory delight. Even Sergei Eisenstein wanted a part in the film, said Buñuel.

Dalí was to develop a point of view about film which had to do with the photographic possibilities of things themselves: he thought of this as anti-artistic, 'the completely new poetic emotion of all the most humble and immediate facts'. [3] Today, he said, 'poetry is in the hands of painters'. [4] In his famous essay about 'the Liberation of the Fingers', he rails against any literary work that doesn't respond to the 'objective record of the world of facts'.[5]

So this is not about fantastic inventions – after all, Dalí had said that to look was to invent. No, it is about the cinematic, and also photographic miracle of things, as in the funny, Dada like spoof-celebration, 'Poem of the Little Things':

There is a tiny little thing placed in a spot high up.
I am happy, I am happy, I am happy.
. . .
My girlfriend has a knee of smoke.
Little charms, little charms, little charms, little charms, little charms, little charms, little charms, little charms . . . LITTLE CHARMS, STING.
. . .
Little things, little things, little things, little things . . .
THERE ARE LITTLE THINGS, AS STILL AS A LOAF OF BREAD.[6]

Something treated in a new perspective modifies its size and so its form, entirely, as we see it: 'A lump of sugar on the screen can become larger than an infinite perspective of gigantic buildings.'[7] Everything was feeling sensual, brand new, open to modification. Take the 'Yellow Manifesto' (*Manifest groc*, March 1928), about the modern newspapers, poets, theatre, art (a salute to Picasso, Gris, de Chirico, Miró, Tzara, Éluard, Aragon, Stravinsky, Breton, etc.) and against the 'sickly sentimentality' of the actual Catalan art. 'Telephone, wash basin, white refrigerators, bidet, little gramophone . . . Objects of authentic and purest poetry! . . . Oh, wonderful mechanical, industrial world! Little metallic gadgets in which linger the slowest nocturnal osmoses with meat, vegetables, the sea, the constellations . . .'[8]

Among his lectures, 'The Moral Position of Surrealism', given to the Ateneu Club on 22 March 1930, stands out as showing Dalí's reading of Freud and his exaltation of the Marquis de Sade, whose writings reveal 'the purity of a diamond', he says.[9] All this for the new generation, who are bound to be interested in Dalí's portrayal of the paranoiac attitude, the 'paranoiac-critical thought' clear in his 'Rotten Donkey' text (published in *Le Surréalisme au service de la Révolution* and dedicated to Gala Éluard) and in the images of *The Invisible Man* and *The Invisible Sleeping Woman, Horse, Lion, etc.* If the 'thought' in that crucial phrase becomes 'method' later, in 1932 or thereabouts, it takes on a greater significance, opening it up to a practice, not just a meditation. We can't forget that Dalí's grandfather committed suicide, nor that according to Freud, paranoia has to do with the concealment of homosexual leanings, nor indeed that Jacques Lacan was to be influenced by the idea, or the thought, or then the method of paranoia, crucial to his own way of thinking. Dalí's father remained as angry as before and Dalí remained as smitten by Gala: see his *Imperial Monument to the Child-Woman*.

Now visitors were about to descend on Cadaqués: René Char, the great poet of the Vaucluse and Paris, who was to join, however

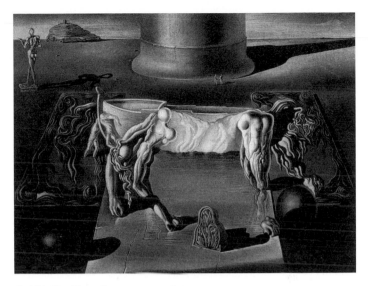

Invisible Lion, Horse, Dormouse, 1930, oil on canvas.

briefly, the Surrealist group through his pal Paul Éluard, and that pal and his recent conquest, Maria Benz, or Nusch. Happy times together, with Éluard still hankering after his past time with Gala. When Dalí published *The Visible Woman*, his first book, Gala's 'wall-penetrating' eyes stare out at us from the cover and inside, and her presence is felt everywhere, especially in the text called 'Love', which has to do with dream, sex and death: we remember Gala's having said to Dalí one of the first times they were together: 'I want you to kill me . . .' It all fits together, with Gala's being such a 'violent and sterilized woman' who, it appears, could not have children because of an operation on her uterus. But she was, and in part because of that, no doubt, adored by Salvador Dalí.

Sex and scandal . . . As for *L'Age d'or*, Dalí's synopsis phrased his idea as wishing to show 'the straight and pure line of "behavior" of an individual who pursues love in the face of ignoble humanitarian and patriotic ideals and other miserable mechanisms of reality'.[10]

The opening was as scandalous as anyone could wish, since it was vigorously attacked by the Patriotic League and the Anti-Semitic League, especially aroused over the moment when a monstrance is taken out of a taxi and tossed into the street. Shouting 'Death to the Jews!' and 'We'll show you there are still Christians in France', they set off smoke bombs, wrecked everything around, cutting the telephone wires, slashing the paintings, stealing the Surrealist books. Then the screen got fixed, the projection started again, the audience applauded and signed a protest against the protest. Chiappe, the police chief in Paris, banned the film, which wasn't shown again in public for fifty years. This is Surrealist scandal at its finest.

Buñuel was eventually to take all mention of Dalí out of the film credits. To the latter, it was especially distressing that his original idea about love and Catholic tradition was altered by Buñuel in the long run. But Dalí was in any case busy constructing his own personal myth about his extraordinary difference from all the others.

> I was considered the maddest, the most subversive, the most violent, the most surrealistic, the most revolutionary of them all. What a power of darkness behind me, therefore, for the radiance of the day when I would build the whirling sky of the Catholic and luminous geometry of all the hierarchic flesh of the angels and the archangels of classicism!
>
> Besides, my own heaven would always remain more violent and real than the ideal hell of *L'Age d'Or*, just as my classicism would one day be more surrealist than their romanticism! And my reactionary traditionalism more subversive than their abortive revolution.[11]

What he was defending in his own reactionary stance was, as he liked to repeat, the entire Greco-Roman civilization.

9

Fame Beginning, 1931–32

Dalí's lectures were becoming famous. He and the Surrealist René
Crevel, a great friend of Gala's, spoke in Barcelona, where again
Dalí was in attack mode. This was the attitude of his 'Moral
Position of Surrealism'. Present day art in Spain wasn't going any-
where, and the bourgeois journalists in the audience were asked to
leave. Everything anti-bourgeois was good, and much of it was
Surrealist. Take the gadgets or 'aparells', as Dalí says, that is, the
many objects scattered all over the surface of *Honey is Sweeter than
Blood*. Take the high-heeled shoes, or/and the glass of milk inside
it, take the black stockings of a lady with raised leg. And in
particular, take Dalí's text 'Surrealist Objects', in another issue of *Le
Surréalisme au service de la Révolution*. The most useful of these (we
are talking, as has become the case now, about paranoia-inducing
things) are the 'Symbolically Functioning Objects' – of which the
perfect example is Giacometti's *Suspended Ball* of 1930–31, in which
Dalí admires the way the cleft of the wooden ball almost slides
onto the sharp edge of the crescent shape. Dalí's own objects made
a great impression, in particular his edible objects, and the whole
idea of cannibalism of objects, which worked wonderfully well with
Gaudí's architectural forms of Art Nouveau in Barcelona, described
by Dalí as 'Modern Style'.

On 15 June 1931 Dalí had a major exhibition at the Pierre
Colle Gallery, with sixteen paintings, including the *Invisible Man*
(1929–31, almost finished), *Little Ashes* (1927), the *Lugubrious Game*

(1929), *The Accommodations of Desire* (also 1929), *Invisible Sleeping Woman, Horse, Lion* (1930), *William Tell* (1930), *The Memory of the Child-Woman* (1931) and *The Persistence of Memory* (1931). Big stuff. No doubt, Dalí's biggest stuff. In *The Persistence of Memory*, there appeared the soft watch, which was to become Dalí's most celebrated image. In the *William Tell* painting, prefigured by Buñuel's photo of Dalí with a shaved head and, atop it, a sea urchin, Ian Gibson sees – convincingly – a perfect portrayal of Dalinian shame, a reference to castration. The grand piano with a rotting donkey alludes to *Un Chien andalou* and, perhaps, says Gibson, to his father's having placed on the piano a book on venereal disease once during Salvador's childhood, thus inspiring in him a panic about maladies. In his 'ancient story' about a 'Christmas in Brussels', the mouth of the Great Masturbator is dribbling blood into the communion cup, near the sacred host . . . truly a paranoiac image. Indeed all these images will reappear and re-re-reappear over the years.

From the point of view of text, his 1931 'poem' called 'Love and Memory' (*L'Amour et la mémoire*) and his 'Rêverie', also of 1931, stand out as major moments. The former is a litanic text, like André Breton's famous '*Union libre*' or 'Free Union' (where the parts of the female body are lyricized one by one, detailed up and down: 'Ma femme à . . . / Ma femme à . . .' and so on. Here is a fragment of Dalí's litanic variation on Gala's body parts and their interchangeability:

> her eyes resembling her anus
> her anus resembling her knees
> her knees resembling her ears
> her ears resembling her breasts
> . . .
> her clitoris resembling her mirror
> her mirror resembling her gait[1]

Gala, *c.* 1930.

On the other hand, the prose text 'Rêverie', equally precise about the parts of the body, has to do with the details necessary for a really good orgasm, first relating the efforts to sodomize a girl called Dulita, who, not very amazingly, turns into Gala.

Now Gala was a difficult item in the world of Dalí's relations and in the world at large. Take her attitude about Dalí's work as handled by Julien Levy: she was ferocious about the painter's rights and recompense. Levy had been one of the visitors to Dalí's first exhibition at the Pierre Colle gallery, and his exhibitions of Surrealism were to be all-important in the life of that movement in the us.

Frustrations were and continued to be everywhere. Just as Dalí's documentary on Surrealism was never made, or at least has never

turned up, so his *Babaouo* never made it to the screen. On the title page, we read: '*Babaouo, an unpublished filmscript, preceded by a synopsis of a critical history of the cinema and followed by William Tell, a Portuguese ballet.*' (Leonide Massine, said Dalí, had wanted to perform this ballet, but things hadn't worked out.) Nor had they worked out for this or a number of other films. What we cannot fail to notice is the exceptional length of this title, like so many of Dalí's titles – in no way could he ever be accused of modest desires or a humble taking up of space. Everything was a muchness of muchness.

On which topic, or one that might be associated with it, Dalí could be thought to be obsessed with breasts and with bottoms. The former he liked small, the latter, large. Think of his idea of having little breasts stuck on behind the womens' backs, so as to appeal to the man following behind: what a grand idea! In light of his breast obsession, it seems wonderfully apt that this should have been the inventor of the brassiere, Caresse (great name for her) Crosby, at whose grand palace in Virginia Dalí wrote *Hidden Faces*. She and her husband, Harry Crosby, ran the Black Sun Press, and owned the Moulin du Soleil, formerly the possession of Jean-Jacques Rousseau, near Ermenonville. Alas, Harry and a girlfriend committed a double suicide, ultimate chic, in 1929, leaving Caresse to entertain a bunch of American, British, and Irish writers, including Julien Levy and the *transition* crowd at the Moulin. The far-off glories of New York were made to seem ultra-appealing, in addition to the encouragement of Levy, Colle, and Alfred Barr. Dalí was short of money, and the trip seemed not a bad idea. Imagine, says Dalí, 'l'injuistic, la monstruosite de moi Salvador Dalí me trouve sans argent' – what a monstrous idea and how unjust to have me without money![2]

Another idea was the Zodiac, a subscription of twelve art collectors, each making an annual payment to Dalí for a painting they would choose, one for each month. 'Save Dalí', the operation

termed itself, and it worked. Julien Green, now having become a great friend, felt that this marked the beginning of his fame, because of the display of these paintings on the much-visited walls of the collectors.

Dalí signed a contract with Skira to illustrate *Les Chants de Maldoror* of Lautréamont, which he designed, but had engraved in some cases by others, as he had done with various other illustrations. This was important as the initial move in his eventual signing of blank pages, which others would fill in. Just as serious, perhaps, was the way Dalí would add to a Picasso print (*Trois Baigneuses* ii) and then engrave their 'collaboration', which was not really one. Picasso was, and was to remain, in Dalí's mind, the one great rival, whereas, from Picasso's point of view, Dalí was not worth a mention.

Obsessions, obsessions. Dalí's pictorial obsession with Millet's *Angelus* was to last his entire life. He spoke of it in the crucial essay 'Paranoiac-Critical Interpretation of the Obsessive Image in Millet's "Angelus"' and its prologue 'New General Considerations on the Mechanism of the Paranoiac Phenomenon from the Surrealist Point of View'. Here Dalí quotes Jacques Lacan's *De la Psychose paranoïaque dans ses rapports avec la personnalité* of 1932, and directly following his essay was an essay by Lacan. Briefly, because Dalí's interpretation is well-known, he finds the eyes of the husband, smaller than his wife (who may be pregnant), downcast to pray but also in shame, as his hat hides an erection. Ah, he is smaller: could it be a son desirous of the mother? And the fork stuck into the earth alludes to intercourse, and so on. And think of Lautréamont's famous dictum about the umbrella and the sewing machine making love on the dissection table: so there is the ploughed earth and the male sex and the castrating female, what else?

For me, the most significant aspect of the paranoia criticism and method to be developed in the early 1930s is the emphasis on misreading, the absolute refusal of a necessarily correct reading.

This would, of course, include any interpretation of any painting or object or text, for example, Dalí's own brilliant and ultra-hysterical interpretation of the Millet . . . The point of his interpretations and theories and get-ups and opinions as they so radically change is, it seems to me, the way they can and do excite discussion.

High time for a Dalí exhibition in New York: the Julien Levy gallery on Madison Avenue hosted it, the public adored it, and the dealer sold a great deal.

10

Fame Increasing, Exhibitions Continuing, 1932–36

So Breton was impressed by Dalí and Dalí by Breton. They were friends. Dalí was making other friends in Paris, through his art and self-promotion and, of course, through his appearance. Gertrude Stein, for example, was charmed by Dalí's looks, particularly his 'most beautiful moustache of any European and that moustache is Saracen there is no doubt about that and it is a most beautiful moustache there is no doubt about that'.[1] His new friend in London, the very rich aristocratic collector and dandy Edward James – whom he had met through the Noailles – was delighted to begin collecting Dalí's works, and entertaining him. But what was Breton, as leader of the Surrealists, to do about Dalí's clearly reactionary beliefs, such as his admiration for Hitler? (Unabashed, indeed. It is the case, however, in his *Vie secrète*, Dalí shouts against being called 'Itlerien': 'déjà la iene de l'opinion publique rode autour de moi', he says, demanding 'que ge me decide infin, que ge deviene ou Estalinien ou Itlerien, NO! NON! NON! Et cent fois NON! Jaller continuer a etre com toujour, et jusqu'a ma mort Dalínien et seulement Dalínien!'[2] ['Already the hyena of public opinion prowls around me . . . that I decide once and for all, becoming either Stalinian or Hitlerian, NO! NO! NO! and a hundred times NO! I will continue to be as always and until my death Dalínian and only Dalínian.'])

The group met to worry about all this at the opening of the Salon des Indépendants on 2 February 1932 in Paris, because of Dalí's having sent to the salon *The Old Age of William Tell* and his

'glorification of Hitlerian Fascism', and then a special meeting on 5 February was convened. Dalí, up to his usual theatrics, kept taking off and putting on items of clothing because of his cold, and his acting and his rhetoric prevented his expulsion. In any case, upon his arrival in New York – prepared by a broadsheet he had decided on with Julien Levy: 'New York Salutes Me' – and given the success of his exhibition, he was now the obvious representative and by far the most famed one of Surrealism. At this point he was calling his way of looking 'Concrete Irrationality' – a perfect mix with the Paranoiac Critical Method – and referring to himself in the third person.

At the Wadsworth Atheneum in Hartford, Connecticut, Dalí pronounced his famous speech ending with the claim: 'The only difference between me and a madman is that I am not mad'. And lectured on *Un Chien andalou* (from the next showing of which, he found, Buñuel had removed his name from the credits!). And in January 1935, he lectured at the Museum of Modern Art in New York on 'Surrealist Paintings and Paranoiac Images' with a large dose of Freud and the subconscious – you didn't have to under-

Dalí and Man Ray photographed by Carl Van Vechten, Paris, 16 June 1934.

Dalí with Gala and
Edward James in
Rome, 1930s.

stand or interpret images, just simply put them down. And he was
eventually to say that his own paintings were the handmade photo-
graphs of his dreams. All this oneiric passion inspired the Dream
Ball or the 'Bal Onirique' given by Caresse Crosby and Joelle Levy
(Julien Levy's wife and the daughter of Mina Loy the writer and
famous beauty). Dalí was dressed as a showcase holding a bra, in
honour of Caresse Crosby's invention of the garment. Gala wore a
red cellophane skirt over a miniskirt, and on her head, a doll with a
small lobster wrapped around its temples, an unfortunate choice at

this point, since it was around the time of the famous kidnapping and murder of the Lindbergh baby, Charles A. Lindbergh Jr, for which Bruno Hauptmann was convicted. And then the Dalí couple left for Europe.

Dalí was still occupied with reconciliation with his father, who, having undisinherited him, drew up first one new will, and then another, by which he would receive an eighth part of the estate. Incidents from his youth recurred frequently in his paintings, for example, the death of his aunt Carolineta, who had died when he was ten, as did, of course, the spectacle of his father soiling his pants. The shame of the father was, in this and other cases, visited

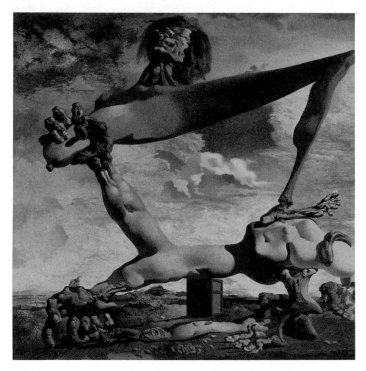

Soft Construction with Boiled Beans (Premonition of Civil War), 1936, oil on canvas.

The Phenomenon of Ecstasy, 1933, a photo collage reproduced in *Minotaure*, 3/4 (December 1933).

on his son, as Ian Gibson so frequently recalls. But for years, the painter's obsession was tied up with his relation to Lorca, as Lorca's was with him. Each found the other full of genius, with reason. In Cadaqués the Dalís remained, the painter working hard, as he always did, rising early, and working all day.

Among the texts on which Dalí worked was one for the *Exhibition of Surrealist Objects* held at the Charles Ratton Gallery in Paris, in May 1935. For that exhibition wrote a text called 'All Honour to the Object!' and showed his *Aphrodisiac Dinner Jacket*, full of glasses containing *crème de menthe*, supposed to arouse all sorts of fantasies. For the International Surrealist Exhibition of June–July 1936, arranged by a group of surrealizing sorts – including David Gascoyne, Henry Moore, Paul Nash, Herbert Read and Roland Penrose, a close friend of Picasso, as well as, on the French side, Breton, Éluard, Man Ray and, for Spain, Dalí himself – he exhibited his *Soft Construction with Boiled Beans*, dealing with self-mutilation and cannibalism: a pure delight later titled *Premonition*

of Civil War. Breton gave his talk on 'Limits, not Frontiers, of Surrealism', and Dalí gave his on 'Authentic Paranoiac Fantasies'. He was continuing to publish in Surrealist journals like *Minotaure*, in which his article 'The Spectral Surrealism of the Pre-Raphaelite Eternal Female' in the eighth issue may have inspired Herbert Read's laudatory remarks on the painter's interest in the Pre-Raphaelites. His fascination in the topic of, the representation of, and the context of masturbation caused no less comment, this from Georges Hugnet. Never one for under-dressing, Dalí prepared himself by appearing in a diving-suit (to plunge into the unconscious, of course), and then – alas, got stuck in it. A can-opener was improvised out of a billiard cue to pry it off him, but the anecdote remains rich material for the imagination, Dalí claiming to have almost perished from asphyxiation. Very good publicity.

Intermission:

The Genius of Detail

So crucial for Dalí's vision, work and writing is the art of the detail in its smallest and widest optical effect, that to mix it up in every case with the ongoing story would muddy it irremediably. He speaks of his 'hypervisuality', dependent on the powerful lenses of his eyes – amplifying an object in a limited field of vision, and its emotional effect. I have chosen a few representative cases to frame here, in the centre of the text, as exemplary, in their pure state. The cases come from 'this sensational book', his *Secret Life*, which has several versions: the original, *La Vie secrète de Salvador Dalí*, now freshly published and commented, the retouched *Vie secrète* presented by Gala, and *The Secret Life* translated by Haakon Chevalier in 1942 and slightly altered in its Dover publication of 1993.[1]

Each of these details sets the stage for an intensity of vision and feeling. Throughout, tiny things are acutely made present, from the Venetian red of the marrow of a chicken bone to the worms in a cherry. Early on, he comments on the skin of Monsieur Trayter:

le gran pousse de sa main la'aquelle havait lepiderme mate, l'odeur la temperature et les rugosites, d'une pomme de terre ride et chafe par le soleill et déjà un peu pourri

the big thumb of his hand which had a smooth epidermis, the smell, temperature, and roughness of a potato, wrinkled and weathered by the sun and already a little rotted[2]

As a model, I am considering how Dalí would trace the itinerary of the shadows on the rocks of the beaches near Cadaqués, when their tops would be caressed by the waves lapping up over them. He would leave traces and signals there at the exact moment chosen, as he did all through his work. In this case, his favourite signal to himself was a dried olive, set upright on an old cork on the tip of a rock, which had a point like the beak of an eagle, and would receive the last rays of the sun, standing alone in the purple light while the rest of the landscape was submerged in shadow. He would slowly drink a bit of water from a fountain, look at the olive 'poised upon the ultimate point of day', put it in one nostril, blow until it came out, pick it up and suck it before putting it back into his nostril.[3]

Which prepares the stage for a later passage in which he finds, again in his nostril, a compressed ball of the blue receipt of a telegram he had sent in order to have some money paid him . . . This kind of 'automatic bit of play' was, he says, characteristic of him in this period, that of the painting of the *Invisible Man* and the writing of *The Visible Woman*, in contrast to the earlier painting, *Invisible Woman*.

It is the same period as his concentration on the skin of a lady's wrist, or then on certain teeth, and in particular, on one tiny little tooth which he wanted to hang from the ceiling to inspire him. Gala's teeth were 'so perfect, so well-shaped, regular and categorical, brilliant and glorious'. These were true teeth as opposed to the lie of his own, in his mouth of an old man. 'Not a single tooth was where it should be. I lacked two molars that had never grown, and the two incisors of the lower jaw, which were milk teeth and which I had lost, did not grow out again (in fact they never have); still other teeth grew where they were not supposed to.' Next to Gala's perfect skull, his was 'a veritable cataclysm, for aside from the chaos of my teeth, my extremely underdeveloped chin would offer a violent contrast to the decisive development of my superciliary arches, which would be monstrously

avid of sight once sight was absent'.[4] Staring at the close-up detail has the remarkable effect of making the ordinary object unrecognizable.

In the *Vie secrète*, he meditates on why he wants to hang up his milk tooth, as a fetish for and after masturbation, and connects it with the white of breasts, the giving of milk, and compares it to the way the melons spurted when the linden flowers were harvested – all these scenes aid in his masturbatory rituals:

> My dear teeth, impoverished, uneven, and calcified! stigmata of my age! From now on, I will have only you to bite into money with![5]

As Finkelstein points out, the visual riddle titled 'Liberation of fingers' of 1929 seems to emulate Breton's autobiographical material in his novel *Nadja*, and to prefigure the relevations in Dalí's *Secret Life*. It can be seen as 'a collection of minutely transcribed objective facts, constituting an object that we find to be difficult or impossible to identify . . . There are eighteen buttons, the one closest to me has a hair (from an eyelash or a tiger) that comes out of one of the holes. Three centimetres to the right of the button there is a biscuit crumb.'[6] The minutiae become so small that all the usual objects become unrecognizable to the ordinary gaze.

Photography works the same way, Dalí will say in 1927, because it will know how to grasp 'the most subtle and uncontrollable poetry! In the big, limpid eye of a cow we can see deformed, in the spherical sense, a miniature, very white post-machinist landscape, precise enough to define a sky where diminutive, luminous little clouds sail by.' And later, he says in the same article, 'Knowing how to look is a way of inventing.'[7]

He certainly knew how to look, and to describe the result. The entire project and product of 'living dissection of myself' that makes up *The Secret Life* is frequently focused on parts of the body

or its dress. Often Dalí's close stare at others or himself has to do with clothing, its affect and effect. His high consciousness of his appearance is matched by an equally high consciousness of his own calculated store of energy. He chooses to wear uncomfortable footwear, to twist his feet unnaturally, and to sit in uncomfortable positions, accentuating the pain from all this in a contraction in order to enhance his own performance.

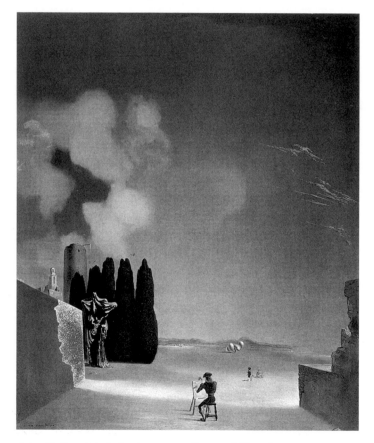

Enigmatic Elements in the Landscape, 1934, oil on panel. The artist concentrates on the enigmatic details surrounding him.

One day when this characteristic contraction coincided with my wearing of shoes that were painfully tight my eloquence reached it height. In my own case physical pain certainly augments eloquence; thus a tooth-ache often releases in me an oratorical outburst.[8]

Or again, in 1928:

Shoes occupying the whole page, perfect products, the eurhythmic play of curves, changes of different kinds, smooth surfaces, rough surfaces, polished surfaces, flecked surfaces; clear, soft, intellectual reflections that indicate explanatory volumes, pure structural metaphors of the physiology of the foot. Marvellous photographs of shoes, as poetic as the most exciting work by Picasso.[9]

To see how this art of the detail plays itself out in his working life – and Dalí was an avid, tireless worker at his craft both visual and verbal – I will take what I think of as the cherry episode. One day he had finished a roll of canvas and decided to paint a still life on the panel of an old door. Spilling out an entire basket of cherries on the table before him, with the sunlight streaming through the window to brighten the fire of their color, he planted three strokes on each painted cherry: vermillion, carmine, and white. The dabs of paint he placed in exact accord with the sound of the mill outside: 'tock, tock, tock . . . tock, tock, tock . . . tock, tock, tock', leaping around to keep up the rhythm. For this he had an audience of peasants, admiring, but one pointed out that there were no stems to the 'joyously born' new cherries. So Dalí began to eat the real cherries and glue each stem of the swallowed ones to the wooden door, whose wormholes now seemed to belong to the painted cherries, whereas the real cherries, equally worm-infested, also had holes. An idea (a very Dalínian idea), which the painter found 'unbelievably refined':

Armed with a limitless patience, I began the minute operation (with the aid of a hairpin which I used as tweezers) of picking the worms out of the door – that is to say, the worms of the painted cherries – and putting them into the holes of the true cherries and vice versa.[10]

And then in the *Vie secrète*, he speaks of a rocking chair, where he is eating cherries and the chair is covered with a kind of lace that has big thick plush cherries. The sun as it strikes the closed shutters lights up the round knots in the wood to a fiery red, like the ears of the person sitting there.[11] All these passages seem to coalesce in the mind of the reader as Dalí obsesses about this red, this shape, and these associations.

'That shows genius', said Ramón Pichot, who had come up to look at the work, as of course it did and does: this genius of the detail is what sets off Dalí's way of thinking, seeing and working from the other Surrealist and *surréalisant* painters and writers. The 'living dissection' of himself realized by his telling of his life in whatever version we read it is full of such incidents, giving to the avid reader as to the avid viewer an intensity of vision that an unread observation of the paintings cannot equal. They are what gives to his life, as I see it, its own 'well-defined shape'.[12] So I have wanted to set off these examples of this bizarre genius from the ongoing if brief recounting of his 'life', the 'secret' and 'public' parts, however they seem to merge. As Dalí says of his various memories, however and whenever they are recounted: 'The difference between false memories and true ones is the same as for jewels: it is always the false ones that look the most real, the most brilliant.'[13] I believe, given all this and much more, that we can claim that Dalí is in the details.

Lorca Dead, Narcissus Alive, 1936–38

Federico García Lorca had been murdered by the Guardia Civil, in his own Granada, where Dalí had not gone to visit him. In his *Secret Life*, the painter comments on this, as an execution for political purposes. For 'personal reasons', he said, 'like myself, Lorca had personality and to spare . . . Lorca's tragic sense of life was marked by the same tragic constant as that of the destiny of the whole Spanish people.'[1] He remembered – how could he not, how could we not? – the way Lorca had acted out in the Residencia his own death and burial, even his decomposition. And he was never to not be remembering Lorca, the seductive and brilliant poet, whom he had so loved.

Off to New York again, then, and this time for the Museum of Modern Art's show of *Fantastic Art, Dada, Surrealism*, prepared by Alfred Barr. Surrealism was very big. These were good times. Edward James, the wealthy eccentric collector and ever the generous friend, arranged to help the Dalís by purchasing all his work for a year, paying him in monthly instalments. He felt rich. He was rich. Julien Levy's book on the subject, beautiful and full of Dalí, was coeval with the appearance of Faber and Faber's book *Surrealism*, by Herbert Read. The show opened on 9 December 1936, and was packed morning to night. Dalí's *Illumined Pleasures* (1929), his *Persistence of Memory* (1931), and his *Soft Construction with Boiled Beans: Premonition of Civil War* (1936) attracted special attention. The preface to the catalogue by Georges Hugnet was not

pleasing to the painter, because of its emphasis on Dada and its downplaying of the unconscious: why hadn't Breton written the preface himself, Dalí asked?

In any case, Dalí was off to Hollywood, to see Harpo Marx, in January 1937. They were to do a film, which, like so many other Dalí films, was never to appear. The script, yes, but not the film.

Narcissus was indeed the perfect myth for the painter, and works both visual and verbal consecrated it: *Metamorphosis of Narcissus*. Dalí had read his Freud. In *The Interpretation of Dreams*, paranoia is considered a defence against homosexuality, and now Dalí added to his set of figures, along with *The Great Masturbator*, a *Great Paranoiac*. How convenient to have one's own obsessions so well analysed by the Great Analyser. Over the years, Dalí had tried to see Freud in Vienna, and once found the whole afternoon marked by his absent image. Back in his room, that image 'stays stuck all night in the curtains of my room in the hotel Saguer, the curtains the most impenetrable, poetic, and tired in the world'. Freud left Vienna on 4 June 1938, under heavy surveillance by the Nazis there, stopped in Paris, and arrived in London on 6 June. So Dalí finally managed to see him there, on Primrose Hill, on 19 July 1938.

In the poem by Dalí about Narcissus and the poet, the latter, Lorca, survives:

> Narcissus, you are losing your body,
> carried away and confounded by the millenary
> reflection of your disappearance
> your body stricken dead
> falls to the topaz precipice with yellow wreckage
> of love[2]

As with St Sebastian, each of the potential lovers represents and is represented by the mythical figure: so Narcissus is referring to

The Great Paranoiac, 1936, oil on canvas.

Narcissus. Now in the poem also, there is another, the female equivalent, the flower narcissus coming forth from the head in the painting:

> When this head splits open,
> when this head crackles,
> when this head explodes,
> it will be the flower,
> the new Narcissus,
> Gala –
> my narcissus.[3]

Edward James, whom Dalí was later to meet, always claimed that Dalí was primarily homosexual. Gala, he said, was able to channel those impulses into his erotic work, and as for Gala herself, Dalí said to him that he let her take lovers whenever she wanted, that he actually encouraged her, 'parce que cela m'excite' ('because it excites me'). Dalí was introduced to Freud by the writer Stephan Zweig on 19 July 1938, along with Edward James the eccentric collector. Since his collection has so many objects that call out for Freudian interpretation, the introduction is of special note. Excitedly, Dalí notes in his version of *The Secret Life* (where the spelling, uncorrected, is irresistible):

> *Nous ne somes pas encore remis de l'émotion de cette nouvelle que ge pousse un cri: ge biens de decoubrir instentanement le secret mhorfphologique de Froid! Le crane de Froid et un escargot! Son serveau et en form d'aspiral! . . . le crane de Rafael et le plus a l'opposse de celui de Froid il est octagonal, come une pierre taille . . . Le crane de Leonardo est comme une noi que l'on ecrasse . . .* [4]

We hadn't yet recovered from the emotion of this news when I let out a yell: I had just discovered the morphological secret of Froid! [he writes Froid, as the Catalan pronunciation of Freud sounds] Froid's skull and a snail! His brain in spiral form! . . . Raphael's skull is the most contrasting with that of Froid, it is octagonal, like a cut stone . . . Leonardo's skull is like a hazelnut crushed . . .

Much in Dalí's life had to do with voyeurism, and with staging what would excite him. We have already seen how 'Reverie' has to do with setting the stage for 'it' or masturbation, and that kind of landscaping was never to cease. In 'Dalí's Small Stage of Paranoiac Ceremonial' Haim Finkelstein examines the work *Endless Enigma* of 1938, as one of the beach scenes full of 'systematic structures'.

Despite its apparent fragmentation, the coherence informing the various associations and relationships is based on a tabletop or stage conception of painting, that kind of spatiality on which the stare and its participation in the spectacle depend. The woman's head juts at a certain angle into the painting, so she can take part in what happens, her eyes probing behind what is actually visible and engaging the spectator in her own gaze.[5]

Staging, staging and spectacle. Many of Dalí's works have a gallery effect and a staged quality, framed and visibly so, with well-defined platforms and pedestals, to construct the beholder's method or viewing, and a precise vanishing point or then several, to confuse things.[6] See his *Illumined Pleasures*, *The First Days of Spring*, and the reliefs of *William Tell* and *In Memory of a Child-Woman*. Some works have painted glass panels, some are foreshortened, like the Italian architect Palladio's proscenium arch. Here and there, a line extends into space.[7]

Never mind how strangely we the spectators are situated. As James Elkins points out, much of what the mannerist conception of staging does is to set things up as if we were badly seated: we are either too low or too far to one side to see correctly. The plane is tilted, and there is a diagonal recession into space, as in the baroque: see *The Font* of 1930. We can drop directly from the plane's edge into a chasm, as in *The Great Masturbator* and *Illumined Pleasures*. And on top of that, as in de Chirico's *The Disquieting Muse* of 1917, the horizon is lost to view, so we cannot situate ourselves correctly, or then the objects are too near the horizon for our pleasure.[8]

In the 'Documentary of Minutiae', there is an osmosis between reality and surreality, between the micro and the macro, as the focus on the minute gains in intensity what the panorama might lose. Dalí never loses sight of the fact that arrangement provokes emotion, thus, of the effect of all this perspective distortion. So the landscape for a properly dramatic masturbatory experience is care-

fully brought about in his text of 1931 called 'Rêverie', and Gala's own sterility ('Femme violente et stérilisée') is a perfect universal and not just private symbol of the precision of 'mathematical space and time'. Here Finkelstein refers to the text 'L'Amour', in *La Femme visible* of 1930.

The essential idea is that, as the body image is circumscribed in a particular space to permit its control, the work manifests its own mastery over the viewing of it. So, in 'Rêverie', a mirror permits the performer or masturbator to see himself from the back. Everything is about presentation rather than representation, about performance and causation, as in J. L. Austin's work on the performative speech act that causes somone to do something, cited by Finkelstein, who refers to the figure of the demonstrator, the person in the work who signals where we should look.[9] Elsewhere, small figures act as witnesses, or then Dalí's own eye or that of his 'alienated self', or Gala's open-eyed stare in *Endless Enigma*, subsumes the other images. For the benefit of the viewer, figures often arrange themselves frontally, for the staging.[10] Even the super self-centred Narcissus loses his being in the classical cold of the devouring and Dionysian siren of his own image in Dalí's *Metamorphosis of Narcissus*.[11]

The real issue, one which Finkelstein brings up in his 'Dalí: Espace et perspective', is the eroticization of space.[12] Not only are we permitted, encouraged, forced to act as spectators to a staging of emotional effect – as the would-be private becomes terribly public – but what we see and don't see is full of mysterious anguish. Curtains hide a sexual scene, or we think they do. As Millet's *Angelus* is the expression, however sublimated, of sexual anguish, so the cult of the irrational – Dalí's universal goal, and all the spinning about of the delirious delight of the fourth dimension with its 'spatial curvature' – sets the spectator in a state of deliberate unease perfectly exemplified by Dalí's *Soft Skulls and Cranial Harp* of 1935.[13]

Back to France. Since Spain was torn by the Civil War, the Dalís settled in Paris, at 88 rue de l'Université, and on 17 January 1938, a Surrealist group exhibition at the Galerie des Beaux-Arts made a great splash. Dalí's *Rainy Taxi* occupied the lobby, with a voluminous amount of water pouring down on two mannequins, one shark-headed, the other crawled over by snails. Then there was the long street of models or mannequins by the Surrealists: Man Ray, Duchamp, Miró and others. However, in 1939, in Paris, Breton stated in the last issue of *Minotaure* that he had severed all ties with Dalí, who had continued to allege that all trouble was racial in origin.

Despite his individualism, Dalí was at the moment finding his influence in decline in Europe . . . Breton's article, 'The Latest Tendencies in Surrealist Painting' effectively expelled Dalí from the Surrealism movement, and it was reminiscent for the painter of the time in 1926 when he had been thrown out of the Royal Academy School of San Fernando. On the other hand the Metropolitan Opera was about to produce his ballet *Bacchanale* with Coco Chanel's costumes, which she insisted Dalí would have to supervise in New York. No, said Gala to the idea of his crossing the Atlantic: this continued, with Edward James volunteering to help, Dalí refusing that help, and himself writing a *Declaration on the Rights of Man to His Own Madness* . . . The following year he and Gala went to visit Caresse Crosby in Virginia. On 14 June the Germans occupied Paris. He had found Spain impoverished, and there seemed no other recourse except to go back to America. He was not to return to Europe for eight years.

Fame continued unabated for the man *Time* referred to as 'a handsome 32-year-old Catalan with a soft voice and a clipped "cinemactor's [*sic*]" moustache, Salvador Dalí'. He had a great talent for publicity, said the magazine, and indeed, this was never not to be the case. Whatever he did, wherever he went, Dalí was recognizable and recognized. In any case, his 'individualism', he said, had grown even stronger, and he was working with furious intensity –

as he wrote to Buñuel, now in Hollywood. In another letter, he wrote of his 'FRENETIC EGOISM', the need to control every situation. Buñuel needed money? He was unwilling to help him, and this letter of refusal Buñuel carried around in his wallet for years. Clearly, some actions or non-actions are never forgotten, and so much for friendship.

12

America's Dalí, 1939–48

The most noteworthy occurrence of the Dalí phenomenon in America was probably the events surrounding the two windows he produced for Bonwit Teller's, at 57th Street and Fifth Avenue. This was a double illustration of the 'Narcissus complex', with day on one window, and night on the other. Day was a bathtub lined with Persian lamb and filled with water, narcissi on the surface and three wax hands holding a mirror emerging from the water. A very dusty mannequin in a black gown with red hair was about to sit in it. Night was a bed with buffalo legs and black satin sheets beneath which a wax mannequin was resting her head on a pillow of live coals, with another heaped in jewels of which she was dreaming. The caption reads: 'She was a Surrealist Woman, She was Like a Figure in a Dream.' This bathtub consecrated an 'authentic Dalinian vision'. After an evening at the opera hearing Wagner's *Lohengrin*, Gala and he had arranged the window until six in the morning, with such passion that 'Gala had ripped her whole dress, so much ardour she put into hanging all the fake jewels'.[1]

But the store's directors changed the mannequins in the windows for their 'ordinary store mannequins', ruining his conception and threatening his reputation for originality: 'l'adulteration de mon heuvre pouvait nuir a ma reputation'.[2] Here is Dalí's description, in his inimitable French: 'Gala conprit par ma paleur subite, et par la sobriete de ma reaction que jAvais devenu subitement dangereux [*sic*]'[2] ('Gala understood by my sudden pallor and by

the soberness of my reaction that I had become suddenly danger-
ous'). So then, he found himself full of energy and anger: 'ge me
sentais comme le senson viblique entre les colones du temple'
('I felt like the Biblical Samson between the columns of the temple').[3]
He decided to tip over the bathtub, but 'the bathtub was much
heavier than I had calculated and before tipping it over it slid near
the window, so that when with a supreme effort I succeeded at last
in tipping it over it broke the pane in a thousand pieces'. Scandal
erupted. Of course the crowds (this is Dalí exaggerating – a typical
Dalí exaggeration) who had massed in front of the windows to
contemplate Dalí doing his tremendous act were terrified of all
that glass on the sidewalk. So he thought it better, instead of
exiting through the store, to go out through the window:

> I considered the situation coldly and judged it far more
> reasonable to leave through the hole of the window jagged
> with the stalactites and stalagmites of my anger . . .[4]

He then took ten steps toward his hotel, and was arrested. This
happened on 16 March 1939, causing a lot of good publicity just
before his exhibition at Julien Levy's Gallery opening on 18 March.
Smart move.

Undaunted, the painter accepted a contract to install a
Surrealist pavilion for the New York World's Fair. 'Dream of Venus',
he called it, wanting to top a Botticelli Venus with a fish head.
Under a red satin bed, 'The Ardent Couch', on which some naked
Venus was lying, lay a tank with bare-breasted girls . . . very daring.
But again, the design was modified. Instead of what he wanted:
'they kept bringing me horrible mermaid costumes with fish tails
of rubber.'[5] And Dalí continues by saying he realized it would all
end up AGAIN in a mess: that is, in French, 'finir en queue de
poisson' ('end badly'). So Dalí and Gala left for Europe on the
Champlain, on 6 June 1939, even before the fair opened.

On 16 August 1940, Dalí and Gala – *DalíGala* as he now termed them – arrived again in New York's harbour. But here is a shock. With the decline of his anamorphic vision in the second half of the 1930s, Dalí was now making an attempt to come nearer to the terra firma of Euclidian space, and becoming the opposite of what he might have seemed to be: no longer a revolutionary in his art or thinking.[6] To everyone's surprise – given his previous incarnation

Galarina, 1944–5, oil on canvas.

of Surrealism ('surrealism is me') – now he represented classicism. *The Secret Life*, his forthcoming autobiography, he said, would show how he had moved from being the figure of Surrealism incarnate to being the saviour of modern art. It would also, he wrote to his sister, make things all right with his family, in particular, his father. The couple remained ten days at the St Regis Hotel on 57th Street and then moved down to stay in Virginia with Caresse Crosby at her old plantation of Hampton Manor, with its lake and horses and servants, and their fellow guests, Anaïs Nin and Henry Miller. The couple seemed so small, said Nin to her diary, and appeared so unremarkable. Gala was relatively put out because Nin and Dalí insisted on speaking to each other in Castilian, which had the effect of shutting the others out.

Gala was not infrequently the cause of discomfort everywhere she stayed. But she was transcribing *The Secret Life* and was always as necessary to Dalí's life as ever. She had copied *The Secret Life* in handwriting, and made her own adjustments to the manuscript. It was to no one's surprise that in it the painter was now given credit for the entire job of Surrealism, as he rejected automatism and created the Surrealist object (!), and the anti-Catholic stance of the films was now blamed entirely on Buñuel. In this volume, everything is mixed up, and the chronology is confused. The narrative merges fact and childhood, falsehood, truth, and above all, Gala, with the rest. By 1942 Dalí had become, he said, a Catholic, and the world needed just that. The book unleashed a series of attacks from all sides: Buñuel was furious that Dalí was blaming *L'Age d'or*'s anti-Catholicism on him, Orwell was railing against the decadence of the author, with his coprophilia and his necrophilia, Clifton Fadiman was calling it a nightmare. And yet the collectors abounded, especially Reynolds Morse and his wife Eleanor, who were to remain among the most faithful clients of Dalí's art their whole lives. Commissions for portraits poured in. The infamous text helped the famous painter.

Everything helped his fame, and he seemed to do everything, choreographing and making the sets for ballets and for Hollywood, arranging spectacle after spectacle. Only the explosion of the atomic bomb, on 6 August 1945, came breaking in on this series of creations. From now on, Dalí said, 'the atom was my favorite food for thought'. This marked the birth of his 'atomic period', in which his *Atomic and Uranian Melancholic Idyll* is the major painting. His publicity talent was undimmed, as he published the *Dalí News*.

But things had drifted away from the excitement of his earlier edible architecture and its soft columns (the perfect confounding of one's rational expectations) to all sorts of manipulated objects and 'hysterical sculptures'. In these, the masochistic column 'allows itself to be devoured by desire', while the caption at the base seems to say 'eat me!' Art Nouveau influences the 'first edible houses, the first and only eroticizable buildings'.[7] A painting of 1941 called *Soft Self-Portrait with Fried Bacon* shows the gradual decline of soft forms and multiple images into a formless caricature and imitation of the former manner, a sense of fatigue and self-emulation as opposed to the tenseness of those earlier obsessions.[8] So, in place of the jacket with the fifty glasses of liquor to inebriate eye and mind, we now have this object:

A woman's shoe, inside which a glass of warm milk has been placed, in the center of a soft paste in the color of excrement. The mechanism consists of the dipping in the milk of a sugar lump, in which there is a drawing of a shoe, so that the dissolving of the sugar, and consequently of the image of the shoe, may be observed.[9]

During the writing of his *Secret Life* from 1944 to 1948, Dalí was offered hospitality and space for writing in Virginia by Caresse Crosby. She would come home to find the painter writing, and Henry Miller, the writer, painting his watercolours. But the Dalís

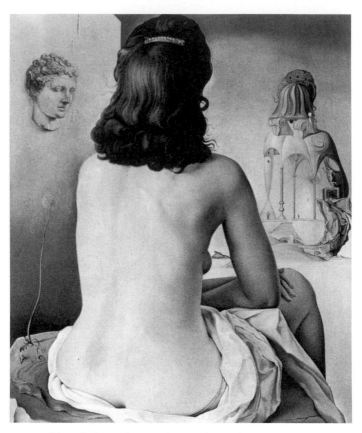

Portrait of the Back of My Wife Contemplating Architectural Form, 1945, oil on wood.

also resided in California, near Monterey, and had a studio in a
villa at Pebble Beach, in 1940. So many places, so much writing.

In these eight years they spent in the US, from 1940 to 1948, the
Dalís met many and worked with many of the more interesting and
more eccentric persons around, including the Marquis de Cuevas
(who formed the famous ballet company). Dalí had, from 19 Nov-
ember 1941 to 11 January 1942, his first complete retrospective
exhibition at the Museum of Modern Art, which then travelled to

eight cities in the US. What a number of things he did: decorating the apartment of Helena Rubinstein, writing stories, designing clothes, costumes, and sets, and directing the production of ballets: *Labyrinth*, García Lorca's *El Café de Chinitas*, *Sentimental Colloquy*, and the best-known, *Bacchanale* (originally entitled *Mad Tristan*), at the Metropolitan Opera in New York City, on 9 November 1939. Coco Chanel had refused to send her costumes to New York unless Dalí were there to supervise: 'the most luxurious set anyone had ever conceived for the theatre, real ermine and real stones, and the gloves of Louis II were so heavily embroidered that we worried it might bother the dancer but again the work was ruined . . . the costumes were improvised [instead].'[10] He published his astonishing (and wonderfully titled) *The Declaration of the Independence of the Imagination and the Rights of Man to His Madness*, defending his fish head atop Botticelli's Venus for the World's Fair in Queens. He illustrated many works, such as *Don Quixote* (1946), *The Essays of Michel de Montaigne* (1947) and two of Shakespeare's plays (*Macbeth* in 1946, and *As You Like It* in 1948).

Dalí's outfits and personality, to say nothing of his looks (which everyone always said much of), were featured in the upscale journals of *Vogue*, *Harper's Bazaar*, *Town and Country*, and so on. 'How you dress is vital for success. I've rarely sunk to the level of dressing in civilian clothes. I always go in Dalí uniform', he said.[11] His vital gift for decoration in the large sense had also led him, in the years 1935–6, to make quite extraordinary furniture for Edward James – including the red plush sofa in the shape of Mae West's lips, a piece which serves as the centrepiece (this is the time to use the word!) of a Dalí painting *Twilight of the Lovers*, and to form the centre of the Mae West room in the Teatre-Museu in Figueres. James's collection was featured in the exhibition at the Boymans Van Beuningen Museum at Rotterdam, November 1970 to January 1971.

One of Dalí's more interesting engagements during his US stay was his involvement with the Wadsworth Atheneum in Hartford,

whose director, Everett 'Chick' Austin, acted, along with Julien Levy, as the first US sponsor of Dalí. His relation to the Wadsworth and to Austin has been described in detail by Eric M. Zafran.[12] The real relation began in 1931 with Austin's exhibition. Three early and realistic Dalís had been exhibited at the Carnegie International Exhibition in 1928. Then, Dalí had had his first one-man show in Paris at the Galerie Goemans in the autumn of 1929. But at a show in the Pierre Colle Gallery in Paris in 1931, Julien Levy bought the celebrated small work *The Persistence of Memory* and thus began Dalí's introduction to American audiences. Austin coveted that painting, and so in 1933 he brought it back to Hartford for a show he called *Literature and Poetry in Painting Since 1850.* The small but perfectly conceived painting was hung between Gérôme's *Eminence Grise* from the Museum of Fine Arts, Boston, and a Kandinsky improvisation, which would have dwarfed it, had it not been so powerful.

In November of 1933, Austin and James Thrall Soby arranged a screening of Dalí and Buñuel's *L'Age d'or*, which had been presented at Levy's Film Society that March. It was shown in Soby's West Hartford house, causing some worry to the projectionist, who feared the police might come, and some grave concern to the Roman Catholics in the audience, many of whom had absorbed too much liquor and threatened to destroy the film. Luckily, said Soby, the staircase was very narrow, and 'it only took one reasonably fat person to block it entirely. I knew we and the film were safe . . .'[13]

In April 1934 Levy put on a show of Dalí prints, and then in the autumn a solo painting exhibition. For this, Salvador and Gala brought the paintings themselves in November, arriving by ship for their first visit to America. The small masterpiece *Paranoiac-Astral Image*, with its boat on dry land containing images of Gala and the child Salvador in his sailor suit against a sunlit landscape of a mysterious kind of beauty, was purchased by Austin for the Wadsworth Atheneum. In December the Dalís went to Hartford

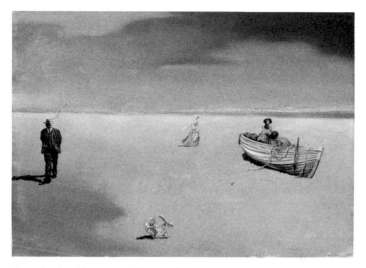

Paranoiac-Astral Image, 1934, oil on panel.

to attend the founding premiere performance of the School of
American Ballet, arranged by Lincoln Kirstein and George Balanchine
– a historic occasion. No less historic was Dalí's lecture in Hartford
the same month, called simply 'A Conference in French with Salvador
Dalí'. There was also a showing of *Un Chien andalou* and the usual
ensuing scandal. Of course, the media took notice, as they usually
did of Dalí's undertakings. A 1936 cover of *Time* featured him,
moustaches and all.

During their stay in the US the Dalís would go to Hartford for
weekends, and visit the Sobys in nearby Farmington. To satisfy one
of Dalí's odd wishes, Soby had to pile a heap of logs around his bed
before he would go to sleep.[14] And in the daytime, they would all
look for four-leaf clovers, in accordance with Gala's wishes. Dalí
was no less picturesque than usual. When Soby invited him to
lunch at the staid Hartford Club, Dalí wore his liberty cap, adorned
with a plate of fried eggs. He was prepared to speak to the assem-
bled club members, but, to Soby's relief, the speech did not come

Dalí and Gala at Soby's home, Farmington, Connecticut, 1939.

off, and the club members continued their lunch, Dalí-less. There remain in the Wadsworth Atheneum's archives several photographs of Dalí's visits to Farmington, but alas, none with the fried eggs and cap. It is worth recalling the painter's childhood game, when he would get down on all fours and swing his head back and forth to the point of dizziness:

> With eyes wide open, I could see a world that was solid black, suddenly, spotted by bright circles that gradually turned into eggs fried 'sunnyside down'. I was able to see a pair of eggs in this condition . . . as if in hallucination . . . I felt that I was at the source of power, in the cave of great secrets.[15]

It was always time for something new, even when it meant reinvention and reuse of present material. Gala and Salvador Dalí had been signing works as if they were one person since the early 1930s and now in the 1940s it was always the case. *Hidden Faces*, the very peculiar novel of 1944 that was written in Caresse Crosby's majestic

house, presents the theory of unconsummated desire or 'Clédalism', named for its heroine Solange de Cléda, a name in which, as Ian Gibson points out, there already was Dalí and also Leda, as in the painting of *Leda Atomica* of 1949. (My original reason for undertaking this biography was my initial reading of this strange text, about which I had heard precious little discussion.)

The novel opens on the landscape of Grandsailles' château, where we are shown the largest snails in the whole of France, and a whole forest of cork trees with their spiny leaves,

> whose touch alone sufficed to isolate the Count from the rest of the world. For of all the continents of the globe Grandsailles esteemed only Europe, of all Europe he loved only France, of France he worshipped only Vaucluse, and of Vaucluse the chosen spot to the gods was precisely the one where was located the Château de Lamotte where he was born.[16]

Everything is the best of the best for him, including his svelte Louis Seizième desk, placed in the very best situation, in the perfect spot on the black and white tiled floor, so that he can look out past the balcony at the plain of the Creux de Libreux. All that bothers him is an unsightly gap between the trees, where his woods have been mutilated. The desolate square seems moribund, amid the surrounding vineyard, and the trees 'pitifully wrung their twisted arms' toward the shadows descending. The plain was still washed in the sunlight, the day's survival, and the novel will end upon just that scene, after pages of description of the Count's pursuit by Solange de Cléda, who dies before she gets the limping Count whom she has always loved. He, on the other hand, seems principally fascinated by edible costuming, like Madame de Montluçon's dress, of which the neck and the roses upon it seem quite tempting to the tongue, as he points out to the wearer: 'The neck of your dress is quite edible, including the roses, but for my own taste I should

have preferred to have the caterpillars served in a separate dish, so that one could just help himself.'[17] Who could resist such a come-on?

The dinner scenes are worth lingering over, since the guests are doubled by what is before them, a spectacle that obsesses the already obsessive Count: 'As if hypnotized, the Count looked at the lilliputian images of his guests reflected in the concavities and convexities of the silver pieces.' These shifts of view, as in Dalí's best paintings, reveal a series of rapid deformations, catching 'the most unsuspected relationships and the most striking resemblances with the vanished personalities of their ancestors'. In the caricatures of images that now adorn the bottoms of the plates, the faces are

> caught in the ferocious meshes of anamorphosis, twisting, curling, extending, lengthening and transforming their lips into snouts, stretching their jaws, compressing their skulls and flattening their noses . . . As if in an instantaneous demoniac flash one saw the dazzling teeth of a jackal in the divine face of an angel, and the stupid eye of a chimpanzee would gleam savagely in the serene face of the philosopher.[18]

Nothing is untouched by this meal. Everything is eroticized, edible and terrible. The skin of Solange is compared to the salt and tart of cream cheese, 'evoking the animal femininity of the she-goat'.[19]

The visual reversals we just saw in the dinner scene have a horrendous equivalent in the objects surrounding Grandsailles. A helmet is made to conform to the bones of the feet rather than of the head. Its holes take laces of greased leather. A triangular aperture where the nose should be shows instead a piece of white kid, stretched tightly, with two horrible round holes about which a membrane flutters, causing a kind of instantaneous biological terror, like the soft part of the cranial suture of a baby's fragile head.[20] Cruelty abounds, mental and physical, as in the rest of Dalí's writings and paintings: 'Veronica drove the iron spike of

her will into the shimmying wood of indecision of her mother's hand.'[21] After a night of love-making, this same delightful Veronica kisses the slit mouth of the mask, and then joins her hands 'like a praying mantis'.[22] We know what the praying mantis female does to the male after love-making, so Dalí the novelist does not have to spell it out, as he does much else. As for Solange, dying, her half-shut eyelids show only the whites of her eyes, and even those are not left in peace. And it is in the whites of these eyes, smooth as those of blind statues, that Salvador Dalí's imagination wishes to engrave, and thereby immortalize them at the end of this chapter, the Latin word, 'NIHIL', which means 'NOTHING'.[23]

An Epilogue, entitled 'The Illuminated Plain', encircles the text and its dramatic staging:

> All things come and go. Years revolved round a fist more and more obstinately closed with rage and decision, and this fist, since the character was sitting in a large armchair with his back to us, was the sole thing which it was given us to see.[24]

What the figure is listening to is Wagner's *Valkyrie,* his *Parsifal,* his *Tristan and Isolde,* as his fist strikes the arms of his chair, five times, bringing forth his blood, 'dark black like a cherry!' Dalí exclaims. 'Nothing surpasses the honor and supreme glory of blood!'[25] His hands caress his art treasures, his Vermeer, Boecklin's *Island of the Dead,* Dürer's *Melancholia,* as the two deep holes of his orbits look at you, dessicated by the malign character of his brain. The scene falls on the trees with their human skin, the colour of fresh blood and their forms like the bodies of naked women.

Edmund Wilson's parodic review of *Hidden Faces* contains this delightful sentence: 'Mr Dali allows the millipede and Boschesque crustaceans of his hermetic imagination to caress the tentacular algae of his subaqueous . . .'[26] This exhaustingly brilliant piece of writing is, in my view, the summit of Dalí's middle style, more

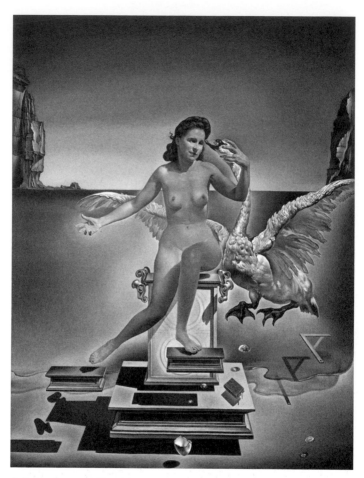

Leda Atomica, 1949, oil on canvas.

clotted than the undeniably great outpouring of undeniably great
Surrealist works between 1927 and 1929 and the pathetic imitations
in his last period of his early work. Nothing is like *Hidden Faces*,
not even the original pages of *The Secret Life* or *Diary of a Genius*.
Hidden Faces, in all its awful horror and sublime lyric cruelty, is
genius itself.

About *Leda Atomica*, then, whose name is already inscribed in *Hidden Faces*, hidden and not hidden, like the sexual dramas unfolding behind those curtains in some of his paintings, Dalí had much of interest to say. For the first time, said he, in this painting, the sea does not touch the earth. So it is a perfect myth, joining 'the human and the divine'. Instead of the confusion of feathers and flesh to which we have been accustomed by the traditional iconography on this subject, with its insistence on the entanglement of the swan's neck and the arms of Leda, Dalí shows us the hierarchized libidinous emotion, suspended and as though hanging in mid-air, in accordance with the modern 'nothing touches' theory of intra-atomic physics. 'Leda does not touch the swan; Leda does not touch the pedestal; the pedestal does not touch the base; the base does not touch the sea; the sea does not touch the shore. Herein resides, I believe, the separation of the elements

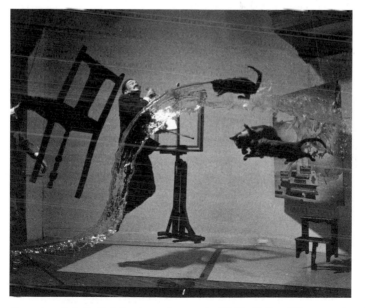

Preparatory study for *Dalí Atomicus*, a photograph of Dalí by Philippe Halsman, 1948.

earth and water, which is at the root of the creative mystery of animality.'[27] This painting, exhibited at the Bignou Gallery, shows, Dalí continues, Gala as 'goddess of my metaphysics'. No doubt its emphasis on not touching has something to do with the non-intimate life of the painter and his wife, each involved with other persons, some of indefinite genders. Maybe it is not a successful painting, maybe the spacing looks odd, the face looks very peculiar, and the swan more so. Never mind: the description makes it all worthwhile, from my point of view.

In July 1948, with their outlandish Cadillac ready to be sent to Barcelona, they were organizing their return to Franco's Spain. Picasso would not allow his celebrated painting *Guernica* – an out-cry against the massacre in the small town on marketday – to be taken to Spain as long as Franco was in power; but the Dalís would return, and did. And the next move, from Leda to landscape, was to come very soon. Gala and his home territory were both always on his mind: Gala had urged him on in buying the shack, had been with him, and was now to be consecrated as the *Madonna of Port Lligat.* Indeed this mattered terribly. Thirty years after painting this latter work, he was still saying: 'I am home only here; elsewhere I am camping out.'[28] In fact, upon his return to Europe in 1948, Dalí made not one but two versions of the *Madonna of Port Lligat*, one of which he actually submitted to Pope Pius xii for his approval – this further underlined his devotion to the ritual and politics of the Roman Catholic Church. Close to his death, he gave further testi-mony to his right-wing royalist sentiments, wanting to present to the King some texts written between 1985 and 1988 titled 'The Alchemy of my Love', in praise of Queen Sofía; 'Ode to the Monarchy'; and a paean to the King and Queen, 'Laureada'.[29] It all worked together: the devotion to Gala, to Rome, and to the Royals.

13

Back Home, 1948–51

Back in Figueres, Dalí wanted to be with his family and his landscape: a photograph shows him with his father and his just published *50 Secrets of Magic Craftsmanship*. His sister Anna Maria, writing her memoirs, did not particularly get on with Gala, who was eager, said Dalí, to see those writings. And she might, said Dalí, be able to show them to publishers. He wanted to see them also, but this was not to happen.

What did happen was the change of atmosphere caused by his new or renewed Catholicism. He hoped to attain religious truth through metaphysics and art, he said, and was delighted that Catholicism was so prevalent in the United States (hooray for Cardinal Spellman, for whom he had a great admiration) and in Spain in particular. Ah, but alas, a very negative review of his *Secret Life* had just appeared in a book by an Oriol Anguera, *The Lie and the Truth of Salvador Dalí* (like Picasso's *The Lie and the Truth of Franco*), with, said Dalí, false paintings, false signatures, and attacking his 'pseudo-Freudian' accent on shit and excrement. So, to reclaim the good opinion of the Spanish authorities, both secular and sacred, his *Madonna of Port Lligat* of 1949–50 was supposed to step in, as it were. Making Gala virginal was a challenging task, as was the development of his new attitude and theory, called 'neo-mysticism', which also covers his *Leda Atomica* of 1949. In his *Manifest mystique*, he describes the 'suspension in space of objects . . . a dematerialization which is the equivalent in physics, in this

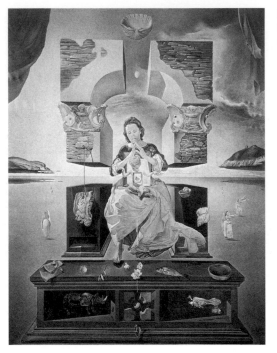

Madonna of Port Lligat, 1949, oil on canvas.

atomic age, of divine gravitation'.[1] This is for him the equivalent of quantum mechanics, and 'his father now was Heisenberg'.

Sets and costumes were fun: he worked on them for a Madrid production of *Don Juan Tenorio*, a Rome production of *As You Like It*, and, in London, a *Salome*, about which the director Peter Brook said he had chosen this painter because his 'natural style' partook of both Strauss's erotic degeneracy and Wilde's remarkable imagery. But Dalí was not in London, which would have been necessary for the production to work. He and Gala travelled to Rome in order to show *The Madonna of Port Lligat* to the Pope, especially since he was planning a larger version and wanted the Pope's approval of it, and on his marriage to Gala. However, Éluard and Gala had been married by the church and so their civil divorce

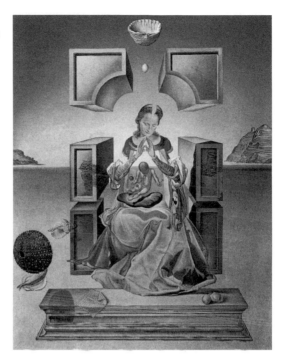

Madonna of Port ligat, 1950, oil on canvas.

wasn't legal. That Dalí should have seen the Pope was the last straw for Breton, whose epithet for Dalí, 'Salvador Dollars', was already pretty on target. Avida (avid for dollars) was exactly what Gala was also, since she gambled, rocketed up prices, and was in general filled with cupidity. There is a second *Madonna of Port Lligat*, much larger and duller in colour: the Madonna, that is, Gala, is older in face, and surrounded by symbols 'that attend her atomic "lift-off" throne'. It is a peculiar mythical scene.[2]

When Anna Maria's *Salvador Dalí Seen by his Sister* appeared, it turned out she blamed Surrealism and Gala for destroying the painter *and* his family. The dreadful scribble on the painting about spitting on his mother was unbelievably out of character, she thought, and the rest we can imagine. Dalí, reading it in New York,

was understandably furious at her 'total hypocrisy: and her equally total falsehoods'. More than that, he was determined to have everyone in Spain know that he was thrown out of his house, expelled from his family, without resources, and that he had – as he said on the cards he had printed and distributed – 'achieved his entire world-wide success solely with the help of God, the light of the Empordà and the heroic daily abnegation of a sublime woman, my wife, Gala'.

Worse still, he was now ready to betray Breton and his past. He found Breton the least adaptable of all people: he was rigid, could not flow with the others or even cling to the walls so as not to be noticed.[3] Of course this is, for Dalí, the ultimate insult, since Dalí loves to be noticed. (Here Dalí brings up the tragic story of the Surrealist René Crevel, who committed suicide, disillusioned by his breakup with Breton and what he found the impossibility of the political situation. Crevel was, says Dalí, an anti-Breton, and his very name – re-né or 'reborn', and Crevel – crevé, 'dead', spoke of his tragedy and the possibility of his rebirth.) Having met Breton in New York after his expulsion from the Surrealist circle, Dalí claims that he triumphed over the materialist and atheistic aspect of Surrealism through his own passionate mysticism, replacing Breton as the true Surrealist. Dalí was ready for his new classicism, and, on top of that, was taken as the truest Spaniard, the person who Knew. So *Vogue* published an article: 'To Spain, guided by Dalí' in May 1950.

Things got larger, as did his work. A large-scale version of the *Madonna of Port Lligat* came out grey. His father died, but Dalí, who had been virtually disinherited, did not attend his funeral. His sister had not returned his paintings, had auctioned some perhaps, and there seems to have been a notarized agreement about finances. Whatever it was, two years later, on 6 September 1951, the notary came to Port Lligat for Dalí to sign the agreement, and when the notary insisted on seeing him – at siesta time, imagine! –

Painting materials at Dalí's studio, Port Lligat in Spain.

Dalí tore up the paper and threw out the notary by force. So of course the latter started legal proceedings, and Dalí asked a friend of Franco to intervene, in a series of smarmy letters. To no avail: he had to show himself to the authorities twice a month, and finally signed an apology to the College of Notaries – all the more interesting in that his father the notary might have been implicated in his head, as if he had removed him from his house in Port Lligat, where he could live an ascetic life, in isolation, and in his favourite landscape of the Empordà. Dalí could always project vision on landscape: 'Oh, nostalgia of the Renaissance, the sole period that

had been able to meet the challenge of the cupola of the sky raising cupolas of architecture painted with the unique splendor of the Catholic faith . . .'.[4] The landscape concurred, and was always made to concur with Dalí's view of himself, saving – against the dreadful stuff of abstract art – the Greco-Roman civilization. What a lecture he then gave, on 19 October 1950, to the Barcelona Ateneu: 'Why I was Sacrilegious, why I am a Mystic'. The crowds crowded in; Dalí had previously insulted a Catalan dramatist, in his

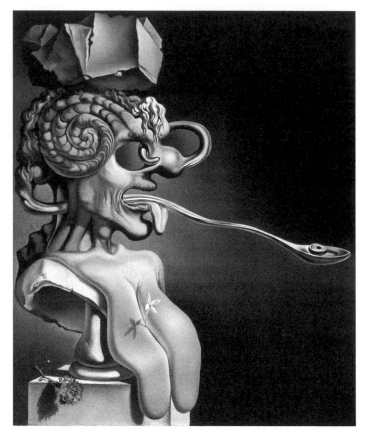

Portrait of Picasso, 1947, oil on canvas.

1930 lecture in the same venue, and he preceded someone who had eulogized his father . . .

Now his canvases are vast: in the *Christ of St John of the Cross*, Christ hangs over the bay of Port Lligat as if it were based on a drawing of the Crucifixion done by that saint. As for the hovering Christ, this figure appears in many works from the 1950s, and he is usually surrounded by some angels. The Madonna and Christ. This is really militant Spanish mysticism. Actually, Dalí's thinking was closer to nuclear physics and relativity theory than to mysticism . . . Nevertheless the painter Michel Tapiès produced a leaflet called 'Concerning Dalínian Continuity', which was inserted in Dalí's *Mystical Manifesto.*

The most impressive and insulting lecture Dalí gave was 'Picasso and I', delivered in English, on 11 November 1951, and it was about Spain. The theatre was filled, the cream of society in Madrid was there, and he could hold forth, as he did:

As always Spain has the honour of producing the greatest contrasts, this time in the persona of the two most antagonistic artists of modern painting: Picasso and myself, your humble servant. Picasso is Spanish; so am I. Picasso is a genius; so am I. Picasso is about 74; I'm about 48. Picasso is known in every country in the world; so am I. Picasso is a Communist; *nor am I.*[5]

The last phrase, so famous now, has that enchanting nongrammatical feel to it, endearing as well as preposterous. (And speaking of Spain, where was Juan Gris in this speech about Spain?) The praise of Franco that the lecture contained was also planned. It finished with a telegram Dalí had sent to Picasso right before the lecture, about Spanish spirituality and the Catholic liberty of the human soul as opposed to the political narrowness and materialism of Russia, about Picasso's 'anarchic genius' prevailing over his Communist leanings, being inseparably a part of the spiritual

empire of Spain, as his work is 'a triumph of Spanish painting. God protect you'.[6] On his side Picasso did not even mention Dalí in conversation. But of course. Then Miguel Utrillo, author of *Salvador Dalí and his Enemies*, has recounted at length the post-lecture banquet at the Palace Hotel in honour of Dalí and the effect of this speech.[7]

At the end of the show, before leaving for New York again, Dalí made a statement about 'the Current Situation of Dalínian Painting' which said, in essence, that it had taken him ten years 'to win my Surrealist battle', and now he would need a year 'to win my classical, realist and mystical battle'.[8] The new current of the times was with him, he said, whereas all the extreme left-wing intellectuals were ranged and ranked against him.

Intermission:

Magic Secrets of Painting

One of the most fascinating of Dalí's works, *50 Secrets of Magic Craftsmanship*, was written during his sojourn in America, and published in 1948. From the beginning to the end, it is riveting. The dedication reads thus:

> At the age of six I wanted to be Napoleon – and I wasn't.
> At the age of fifteen I wanted to be Dalí and I have been.
> At the age of twenty-five I wanted to become the most
> sensational painter in the world and I achieved it.
> At thirty-five I wanted to affirm my life by success and I
> attained it.
> Now at forty-five I want to paint a masterpiece and to save
> Modern Art from chaos and laziness. I will succeed! This book
> is consecrated to this crusade and I dedicate it to all the
> young, who have faith in true painting.[1]

In his 'Clear and Brief Prologue', Dalí's statement melds arrogance and wit, his two main characteristics. 'The two most fortunate things that can happen to a painter are, first, to be Spanish, and, second, to be named Dalí. Those two fortunate things have happened to me'.[2] Indeed, but his reverence for the painters who preceded him, such as Velázquez, Raphael and Vermeer, cuts the irritating language. One drop, he says, of the medium with which Vermeer of Delft painted, placed on one side of the scale, would

easily balance all the rest: the left ear of Van Gogh, the left hand of the painter Dalí 'and an impressive quantity besides of viscera of all sorts . . . for good measure the two ponderous hands of the touching Paul Cézanne'.[3]

And there is something about ages past: each year adds to the value of any object that lasts: 'Empires crumble, and Hitler, the great masochist, lays the foundations of a future Wagnerian opera, dying in the arms of Eva Braun beneath the burning sky of Berlin . . . All this is nothing compared to the patina of a beautiful painting!'[4] And for Dalí, the beautiful painting is in oil, even triumphing over the brush marks of Giotto or Fra Angelico. 'All painting before oil is dry, harsh, and, as it were, against the grain.' Later, the painter can scumble (that is, to press hard against the canvas with the brush or its end) with a badger-hair brush the pigments, 'solarized with the oils and the honeys of light itself'.[5]

So the working schedule for the painter is pretty clear: his secret is his calendar, according to which every important work may be realized in six days. He will of course be before his easel at 8 a.m., and most likely can finish rendering any sky by one o'clock, taking an hour for lunch.[6] As for the siesta necessary in a Spanish climate, it should take something like a quarter of a minute. The way to sleep for not too long is what he calls 'slumber with a key'. You settle yourself in a bony armchair, preferably one in the Spanish style, dangle your wrists in space, once they have been lubricated with oil of aspic. At the moment of sleep, you will feel a tingling in your fingers – you are holding a heavy key between the thumb and forefinger of your left hand, and, as you fall asleep, the key will fall upon the plate you have placed upside down on the floor, and will wake you before you have wasted too much time in sleep. The technique, says Dalí, comes from the Capuchin monks of Toledo.[7]

In any case, the most propitious time for painting is from three to six in the afternoon. And when there are a man and a woman to be painted, it is wise to choose the masculine one first, and to

begin the face with the lighted parts of the chin, then the cheeks and forehead, then the nose, mouth, ears, and eyes. Then from six to eight-thirty, one can paint the backdrop or architecture.

Sleep is greatly to be prized: the Renaissance painters tried to be diverted, to see to it that their minds were elsewhere when they were painting. Dalí quotes Raphael: 'When you paint, always be thinking of something else'. Here Dalí shares with the Surrealists a strong and incessant belief in the power of dream. What you prevent yourself from doing, he says, 'the dream will do with all the lucidity of desire . . .'.[8]

Among the lessons he announces for the painters is one of intensity. You may be painting just a small part of the universe on

Inspiration entering by the five fingers of the hand.

'Inspiration entering by the five fingers of the hand', an illustration for *50 Secrets of Magic Craftsmanship* (New York, 1948).

your bare canvas, and nevertheless 'you will have to make felt all the antipathies of the entire universe'.[9] Some of the ways of portraying these antipathies are, if obvious, still far from expected in their examples. You place some horrid thing next to something it loathes, like an orange with a leaf of lettuce (what a moral monstrosity!) or then you exaggerate the scale of the pictured object, such as sardines too big in size. And pay attention to the colours abhorrent to the sensitivity of an artist: you must avoid flowers around your house (your worst enemy is exotic flora), and you must absolutely shun loud coloration of all sorts. The worst is a green lawn 'and all vegetation in which the green of the chlorophyll utters its desperate biological shrieks for oxygen!' By all means possible, you should 'Avoid . . . the presence of those snotty brats which are the violent greens'.[10] So the climate and the surroundings of a painter are infinitely important. It is clear, for Dalí, that the very idea of a good painter arising from the tropics is fully as ludicrous as that of someone being a good Swedish painter (!). Never was there, says our painter, a single great painter in a country where they would be blinded by snow, that greatest enemy of the retina, therefore there are no good Russian painters, who tend to make all their colours violet-hued.[11]

Dalí promotes the romantic idea of the artist, whose suffering should be made measurable, by staring at the calendar on his wall. Take the agony of Saint Sebastian and the pain of the arrows aimed at him, like so many brushstrokes count out the passion of the painter, which is never finished.[12] And yet, on the other hand – and the Dalinian point of view depends to a large extent on paradoxes – the artist must partake of happiness and good humour in order to see the mysteries of creation. It helps, of course, to have a wife of great nobility, such as that of Gala in her contemplation of Christ on the Cross (see his *Crucifixion*). As a matter of fact, the best thing any painter can do is to marry Dalí's wife, he says, for 'Gala is a creature of grandeur'.[13]

But there are, among these fifty magic secrets for painting, all sorts of surprising suggestions and observations, as one might suspect when it is a question of Dalí. Among them, the statement that, in order to concentrate his attention, or then because of doing so, every painter drools.[14] That spiders are conducive to good painting, unlike dogs, which are not. That the best way to envision the structure of a successful painting is to take the shell of a sea urchin 'in which all the magic splendors and virtues of pentagonal geometry are found resolves . . . look through its pentagonal aperture, called Aristotle's lantern, pierce a hole in the other side of the shell, and place against it the concave face of a crystal lens, across which you draw perspectival lines with the web of a spider.'[15] The natural cupola of the urchin is supremely beautiful – but then, for Dalí, everything about the sea urchin is just that. He would eat about three dozen at a time, lauding above all others those from the nearby Cape Creus. Or he would place it on his head, newly shaved.

Dalí's study of natural forms, as much of his other reading, abounds in learned references. On spider webs, he quotes D'Arcy Wentworth Thompson's *On Growth and Form*; on various motions with the brush, he quotes a treatise called 'A Study of Splashes' (1908), and his own reflections are heavy with detail.

As for spiders and their webs, Dalí particularly recommends those barns bedecked with heavy spider webs, the very best for attaching to your canvas a little paper roof, to protect it from any small particles that might be intent on penetrating the paint. Actually, the Dalinian moustache serves, quite wonderfully, the same purpose, catching any invasive desire. Luckily, the pointed tips of the moustache register each change of light.[16]

And it is much the same with Dalí's paintings: each of them, and each of our reactions to each of them, can be seen as changes of light.

14

Winning the Battle, 1952–60

Dalí's statement about the 'Current Situation of Dalínian Painting' had ended with an attack on the extreme left-wing intellectuals, and then as an address to the partisans of his own mental country: 'With me are the intuitive public, the new current of the epoch, the leading intelligences. I will win the battle for Spanish painting.'[1] That was just before leaving for America, where he lectured about his 'nuclear mysticism'. About that term he wrote in May 1952 that Spain's mission was to ennoble everything by its religious faith. All this was against 'socialist realism' and to some extent against Picasso, his lifelong rival, who would never acknowledge him. Luckily, Narcissus-Dalí had enough self-esteem to make up for the opposing denigrators.

> Narcissus loses his being
> in the cosmic vertigo
> in the deepest depths of which
> is singing
> the cold and dionysiac siren of his own image.
> The body of Narcissus flows out and loses itself
> in the abyss of his reflection,
> like the sand glass that will not be turned again . . .[2]

His self-reflection certainly sufficed to counter opposition with a feeling of self-worth.

In November 1952 Éluard died at fifty-six, and was given a hero's cortège through the streets of Paris (I remember it well, and remember marvelling at a country in which a poet could have become such a national hero). Though Salvador and Gala were then in Paris, they did not attend the funeral, whose main consequence was that they were now able to marry by Church law (which they did not do until 1958). The titles of Dalí's paintings continued to be Latinate and religiously oriented: instead of disintegration and destruction, he claimed to focus on the reconstitution of the Virgin (i.e. Gala) in the heavens. Nuclear physics, of course, and Gala was 'pushed to heaven by anti-matter Angels'.[3]

Conveniently, all this religious excitement in no way opposed the other side of things, the erotic drama projected in such titles as *Erotic-Mystical Delirium* (his three-act play in alexandrines, worked on for twenty years and never finished, perhaps not unsurprisingly!) and *The 120 Days of Sodom of the Divine Marquis in Reverse*. Dawn Adès comments on one of Dalí's paintings, *Anti-Protonic Assumption*, in which Christian dogma becomes a kind of 'superior science fiction'

His time was always to him 'precious and adored' – no reason to waste it on anything.[4] And indeed Dalí was an incredibly stick-to-it worker, hours and hours every day. His whole self-mythologizing was a permanent fixture of his being – the mysticism, 'nuclear' or other, was perfectly wound together with the myths. His myths were self-generating and regenerating, like the *re*-secret life . . .

In September 1952 Dalí was convinced and convinced others that he had a secret and private relationship with angels: one of the annexes of the *Diary of a Genius* is a piece by Bruno Froissart on his relationship to them.[5] Back to Rome, where in 1954 he was suddenly reborn in the Holy City by bursting out of a 'metaphysical cube' surrounded by photographers. At this point, Gala and Dalí were surrounded also by collectors, among them Reynolds and Eleanor Morse in particular, who travelled with them, adored them, collected

the work, promoted it, and so on. What could be better? (Better might be a more balanced view of Dalí in relation to other movements than Dalianism, in particular, as Ian Gibson says, Surrealism, which Morse considered destructive and just a gathering of incompetents. William Rubin, in his *Dada and Surrealism*, judges Morse a better apologist for Dalí's late work, and all agree that his edition of Dalí's journal is invaluable.) Other apologists were to come along, especially the part-Irish Captain Peter Moore (his title inherited from the British army) who acted as Dalí's manager and took ten per cent for every deal. Then there was the man who was afterwards to become Dalí's secretary, Robert Descharnes (for years my neighbour in the Vaucluse every summer, and Dalí's co-director for the film *The Prodigious History of the Lacemaker and the Rhinoceros*).

There came along Isidor Bea, a scenery designer, who was his assistant for the next thirty years, lending his knowledge of scenography to Dalí's large-scale paintings. There came along also, and importantly, the glamorous Nanita Kalaschnikoff (who thought of herself as Andalusian, shades of the much-missed Lorca . . .). And there was the psychoanalyst Pierre Roumeguère, so knowledgeable about mythology, one of the painter's true fascinations, and able to supply him with the idea of the twins Castor and Pollux, a myth into which he could incorporate himself and his dead brother Salvador. Never mind that Roumeguère swallowed the tale about the first Salvador dying at the age of seven instead of at twenty-two months. This was all to the good for Dalí, so Gala could play the role of Castor, so they could now marry in the Church. They did, on 8 August 1958; and Dalí could have another papal audience. Éluard's death had made it easier. Little matters really in the country of Dalí except what he manages to do with his fascinations, his myths, and his incredible genius for publicity. There came along Carlton Lake, the very intelligent and knowledgeable author of *In Quest of Dali*, Enric Sabater, who succeeded Peter Moore as Dalí's

secretary, and others, all helping with and sharing in the later years of the couple's life. John Richardson quotes Reynolds Morse on Sabater, 'the greatest con game ever on the greatest con man in art'[6] and describes the surrounding helpers succinctly as 'creepy, conniving courtiers'. [7]

Other elements besides persons began to people Dalínian country. Along with the rocks of Cape Creus, there came along rhinoceros horns, the DNA molecule, Perpignan rail station as the centre of the universe, and so on. Each played its role in the kind of drama the painter liked to set up around himself. His rhinomania supplied a delightfully outlandish example. It is December 1955, and not particularly warm outside. Dalí arrives to give a lecture at

Dalí in Paris, 1956.

the Sorbonne on the morphology shared by rhino skins, sunflowers, and cauliflowers, with which his open Rolls-Royce was completely filled. He was in his element, imagining a divine sort of transport for the painter Divine: the Ovocipède, just a plastic sphere your foot could move. In this Dalí dressed as a spaceman – why not? That same question could be asked of all Dalí's exploits in his later years, after the inventive bursts of Surrealist work – however one wants to term them, this is surely the most useful qualification for the Dalínian universe, even after his expulsion from the group. Even Salvador Dollars was capable of doing Surrealist work, and that is what this small volume is meant to celebrate. Why not?

Dalí in 1960.

In any case, scandals were an essential part of the Dalí mystique – I choose the word here because of his ongoing emphasis on mysticism and exposure. In December 1960, for the International Exhibition of Surrealism at the d'Arcy Galleries in New York, Dalí hung his *Sistine Madonna* (*Ear with Madonna*). The Surrealists in New York, led by Breton, protested: 'We Don't Ear it That Way', and gave Gala's head from the *Assumpta Corpuscularia Lapislazulina* Dalí's moustache and Marcel Duchamp's randy slogan from his Mona Lisa, *LHOOQ*: 'She's got the hots.'

And his Cadillac again entered Figueres on 12 August 1961, in the midst of a fierce *tramontane* wind, announcing the opening of his museum – minus roof, and just holding photographs of his work. (Dalí, who had in mind a geodesic structure of Buckminster Fuller, of which he had seen pictures, finally was to commission Emilio Pérez Piñero to make a transparent dome of the Fuller variety for the museum, now installed. For Dalí to be thinking up such structures as this is certainly a statement against the formless – a reminder that his neo-classicism was for real.)

He had thought of having a 'vomitorium' also, for visitors to throw up in. On the other side from scandal, Dalí engaged in 1972 the nephew of Ramón Pichot Gironés, the painter friend of Picasso who had, with his Impressionist paintings, so inspired Dalí the year before in Cadaqués. Antonio Pichot Soler displayed his work in the museum, and became essential to Dalí. On 22 August of the same year, in the Teatro La Fenice in Venice, for *The Spanish Lady and the Roman Cavalier*, the spectacle Dalí had devised with Maurice Béjart, Dalí sat in a box costumed like a gondolier, splashing paint on a canvas, which he ripped apart to release twelve homing pigeons, before the curtain rose to show a painted image of his face, his moustache rising to his eyebrows, etc., etc. Then there was *Gala*, with Scarlatti's music, beginning with a wheelchair, a cripple, erotic dancing, and the Supreme Mother, with liquid carbon dioxide like milk cascading – this went from Venice to Brussels to Paris.

The Salvador Dalí House and Museum, Port Lligat Bay, north of Cadaqués.

That was a real Gala, and another appeared in 1962, with Descharnes' *Dalí de Gala* (which became *Salvador Dalí* in English), a successful project, unlike the film they were doing together. Descharnes is intensely knowledgeable about science, and from then on proved a great help to Dalí in his experiments and optical illusions (with the parabolic lenses like flies' eyes), his holograms, his fascination with DNA, and so on. Dalí's painting *Galacidal-acideoxyribononucleicacid*, with its catchy subtitle for those in the know: *Homage to Crick and Watson*.

15

Scandals and Seclusion, 1960–79

There is a paranoiac picture aptly called, in travesty, 'The Last Scandal of Salvador Dalí' (painted under the pseudonym Felipe Jacinto). It has Dalí himself sitting at the Barclay restaurant on the Champs-Elysées, nursing a glass of Armagnac, while Gala listens 'fanatically to the remarks made by Dali, who was in one of his brilliant moods, when ideas, one following the other, exploded like a shower of firecrackers'.[1] We know, from Dalí, how proud he is in 1960 of his looks: black hair, no corns on his feet, and a stomach that has, after his appendicitis operation, regained its slim appearance. He has become doubly a hero, because he has revolted against the authority of his father, who didn't know how to love him.[2] Just like Picasso, says Dalí, always eager to come up against his only rival, or at least to compare himself with him. And after Éluard's death, he is able to marry Gala, again a tribute to his own genius: Éluard, the best poet in France, Dalí the best painter. Of course the latter would acquire the wife of the former!

As usual, John Richardson is delightfully bitchy on the topic of Gala, with whom he had to deal as the vice-president of Knoedler's Gallery in the early 1970s. Most of those who had anything to do with her, he says, 'would agree that to know her was to loathe her'.[3] His picture of her is colourful to say the least: 'In a jet-black wig held in place by a Minnie Mouse bow, this ancient harridan would drive home her wheedling demands for money with jabs of ancient elbows and blows of mottled knuckles'.[4] Not that Richardson's

view of Dalí himself is dreadfully flattering: 'the Wizard of Was', he calls him.

All the irreverencies of *Journal of a Genius* can be inscribed under the rubric of poetic licence with a vengeance: there are pages and pages on the art of farting, even an appendix with an extract from a nineteenth-century volume called *L'Art de Péter or Manual* by the aptly named 'Count of the Trumpet, the Doctor of the Bronze Horse, for the use of the constipated'.[5]

Dalí is now making his decision 'to become classic'. The new American collectors have an awareness that certain things once elegant and impassioning have turned their backs on the previous period, which is 'finished, finished, a thousand times finished'. Over and done with are his former aesthetics, in the epoch of experiments. Former Surrealist practices are out of tune and feel with the demands of the present moment.[6] Something else has to be found to enliven situation and purse. Dalí laments: 'My surrealist glory was worthless. I must incorporate surrealism in tradition. My imagination must become classic again . . . to render the experience of my life "classic", to endow it with a form, a cosmogony, a synthesis, an architecture of eternity. Something lasting has to be found, and the stage set of this "Last Scandal" may help. Provided it has enough juice in it . . . '.[7]

But the juiciest of the scandals, apart from the visual and verbal ones, had to do with the attachments of Gala and Dalí. Gala was always ready for sexual encounters, with men from all walks of life: sailors, collectors, and especially young men of dubious trades. She preferred them very young, very handsome, and very keen for sexual adventure. One, Eric Samon, managed to have her car stolen while he was supping with her. There were many others. The principal one was William Rotlein, addicted to drugs, and who looked like the young Dalí. By 1964, the painter seemed to think she was actually going to leave him, not just for a while, but permanently: 'I need you badly', he would write. But luckily the Albarettos, an

Italian family close to the Dalís, managed to wean her away from Rotlein by brilliant means. They asked Fellini to give the young man a screen test, which of course he failed – causing Gala to lose interest in him. They bought off the photographers and journalists. Finally, Rotlein took an overdose and died.

Among a series of additional lovers, there was Jean-Claude Du Barry, the owner of a modelling agency, who was able to supply many 'Saint Sebastians' for Dalí and lovers for Gala, including Michel Pastore ('the shepherd'). A grand 'purveyor of ass', as Dalí so delicately put it. There was, most importantly, Jeff Fenholt, star of *Jesus Christ Superstar*, on whom much was spent, before he began to blackmail Gala; Dalí found out, and was alarmed. In a fitting, if ironic, end to the story, Fenholt turned to preaching on TV in California, a far cry from his involvement with Gala. But Dalí had been worried Gala would leave him for Christ. So she fed him Valium and other such drugs to calm him, including an assortment of amphetamines, wreaking neural damage on his already enfevered brain . . .

As for Dalí the Great Masturbator, Dalí the Spaniard but specifically Dalí the Catalan, he remained enchanted with himself and his landscape, literal and visual. 'My geniuses are Catalan, my own genius comes from Catalunya, country of gold and ascesis', he says in *The Passions According to Dalí*, conversations with Louis Pauwels that took place near Dalí's landscape, which appeared in March 1968.[8] It is clear that some of the most authentic visions of the Catalan come out in his interchanges with others. To the French poet Alain Bosquet, he had declared: 'A picture's nothing compared with the magic which constantly irradiates from my person'.[9]

Given Dalí's fascination with what we might think of as the kinky, it is not startling to learn that he was smitten by a dancer he wanted to paint as 'Hermaphroditos'. The dancer was George Jamieson, who had been April Ashley when in drag at Le Carrousel,

Paris, and who then, after Dalí had come to see her dance for six weeks, introduced him in 1965 to the large and beautiful Franco-Oriental fashion model Alain Tapp, known as Peki d'Oslo. Both April and Alain had sex-change operations, and made their way to a certain success. Alain, that is Peki, married a twenty-year-old Scot called Morgan Paul Lear, who acquired £50 for the ceremony and never had to see his twenty-six-year-old wife again. As Mrs Amanda Lear, Peki d'Oslo (*né* Alain Tapp), went on to model for Ozzie Clark, to become pals with Brian Jones of the Rolling Stones, and to have affairs with Bryan Ferry and David Bowie, becoming 'The Disco Queen of Europe'. Then she took up with Dalí, and pleased him not just through her beauty but her intelligence, her passion for art and languages, and her need for a father. She put about the story that she and Dalí had been united in a 'spiritual marriage' on a deserted mountain-top. 'My new love', the painter called her. His previous muse, Ultra Violet (Isabelle-Collin Dufresne), had left him to join Andy Warhol in his Factory. Amanda ('L'Amant Dalí') was perfect in the role. Her own account of Dalí in Paris, *Le Dalí d'Amanda* (1984) is useful, as is her knowledge of various sets of mores. She wrote herself about this in *My Life With Dalí* (1986). Even Gala, obsessed by her own affairs, was eventually to put up with the lovely Amanda. Getting Dalí off her case was no small thing.

Dalí's own case remained somewhat the same: monarchist, right-wing-ist, he issued a proclamation in 1968, during the May events of the student uprising, called *My Cultural Revolution* (18 May 1968). Back to tradition, and so on. His court now contained – as well as Ninita Kalaschnikoff, Amanda and assorted others – a young Colombian actor, Carlos Lozano, aged twenty, slim and dark, with a bare midriff, who was happy to participate in the mutual masturbation sessions Dalí enjoyed putting on. It also contained Enric Sabater Bonay, athletic, handsome, and good at making money – he was to edge out Peter Moore the captain. By

this time, Dalí was enjoying coloured spectacles (one lens red, one blue) to yield a 3-D impression, and this led to a fascination with stereoscopic imagery, for which Amanda can take some credit, since she had noticed a painting by the seventeenth-century Dutchman Gérard Dou, in which an object seemed to stand out in relief. Thence, the whole fascination with the stereoscopic, the holograms, and the rest followed.

The Spaniard in Dalí led him to create the *Hallucinogenic Toreador*, in which there is a dog that Dalí referred to as an Andalusian Dog; in short, Lorca was and is present, along with his great poem 'Lament for the Death of the Bullfighter', with its

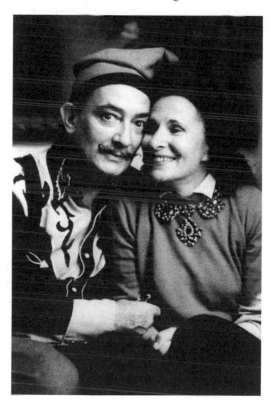

Dalí and Gala,
c. 1960s.

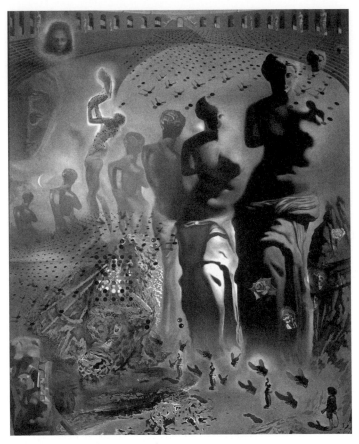

Hallucinogenic Toreador, 1968–70, oil on canvas.

heart-rending refrain *A las cinco de la tarde* ('At Five in the
Afternoon'). Also the moon is remembering the lament, for most
of Dalí's canvases are sunlit.

Back to landscape: Sabater found a mansion called Púbol, and
bought it for Gala to retreat to with her various lovers. It was isolated
and inviolate behind its high walls, and even Dalí was allowed
there only by written invitation. His museum, the Teatre-Museu in

Dalí speaking at the Académie des Beaux-Arts, Paris, in 1979.

Figueres, was slowly getting into shape, and his relation to Lorca was eternalized in the painting *Still Life by Moonlight* (1926), which he now explained as the fusion of Lorca's and Dalí's heads, with their shadows corresponding, like 'the shadow of a self-portrait'. Lorca, never to be forgotten.

One more scandal: that of the blank sheets. Dalí signed some blank paper for Pierre Argillet, a French publisher, to be able to put some Dalí prints on sale. Moore writes: 'Dalí signed 10,000 sheets and this gave us 100,000'.[10] To pay expenses, of course, especially in America, at the St Regis, where he always stayed and ate. He loved signing anything. Gala watched, in amusement, caring only for the cash, which she enjoyed immensely. They both loved

Dalí with Gala,
Paris, 1979.

scandal: witness Dalí's enthusiasm for André Parinaud's book *The Unspeakable Confessions of Salvador Dalí* (from the French: *Comment on Devient Dalí*).

The rest is a sad case. Dalí continued to show his right-wing opinions, to say he was on the side of the Holy Inquisition and on that of Franco, and to quote Lenin, saying: 'Freedom is no use for anything.'[11] Michael Stout took over from the Dalís' previous attorney, and managed the affairs of Sabater and Dalí, called Dalart Ltd, specializing in production rights to his work. Dalí began to rely on anti-depressants, and by the time he was seventy-two, showed definite signs of weakening. He was elected, just before his seventy-fifth birthday, to the Académie des Beaux-Arts of the Institut de

France, and wore a uniform of Napoleonic sort, carrying a gold sword with a swan of Leda atop Gala's head on its own head.

At this point, his focus was on classical art, on the fourth dimension, and on stereoscopy. A retrospective was held at the Centre Pompidou from December to April, and then moved on to London's Tate Gallery. Most of the works were from the Surrealist period. A 'Committee of Friends to save Dalí' was formed, with Descharnes and Morse in charge, but the plethora of drugs given to the painter were taking their toll on his brain, as was his arteriosclerosis on his body. His friends put him in the Incosol clinic, a health farm in Spain, where he was shaking, shrunken, and panicked that Gala was going to leave him for Fenholt. She didn't, of course, but the payments and blackmail extortions were enormous.

16

Endings, 1980–89

Time for another startling public appearance. On 24 October 1980, Dalí held a press conference in his Teatre-Museu in Figueres. As *Tristan und Isolde* played, he came into the room where a hundred journalists awaited him, looking much older, and exhausted in his leopard-skin overcoat. But he declared: 'Here I am!', banging three times on the table, exactly as in the French theatre before the curtain rises, and kissing Gala, who was made up brightly, with her habitual velvet bow on her head. He had, he said, discovered that God was very tiny. And having made this announcement, he unveiled *The Happy Horse* ('you can certainly see it is rotten', said he). Then they were driven away in their blue Cadillac.[1] Great entrance, great exit. Theatrical appearances have to be kept up, and were.

In Paris, they stayed as always in a suite at the Hôtel Meurice, but Dalí's condition was terrible, both mental and physical. Sabater resigned as their secretary and dealer on 31 December, saying Dalí was a great masochist. Shady business had been going on and was continuing to do so – chaos on all fronts, to say nothing of Dalí signing blank sheets for the market. Then all appeared to be put in order by Robert Descharnes, who had now taken over as Dalí's secretary, putting the precarious situation of Dalí's decline and problematic moral and business dealings in order. A Foundation was created on 23 December 1983: the Fundació Gala-Salvador Dalí, with a Committee of Honour including, among others,

Edward James, Raymond Barre, Julien Green and Descharnes. The latter subsequently created an agency called Demart pro Arte BV in Amsterdam, with himself as managing director. But finally the copyright was transferred to the Foundation. The Dalís returned to Spain, and were surrounded by caretakers. The Catalan Prime Minister came to visit, then King Juan Carlos and Queen Sofia. Richardson points out that for this visit, Dalí displayed his forehead dented by a kick from Gala, and had to tidy his moustache.

Gala was operated on for gall-bladder problems, in March 1982, and things went from bad to worse. Cécile, the daughter of Gala and Paul Éluard, went to Port Lligat in June to see her mother, but Dalí and Gala refused to see her, as if rejecting all things in the past. Gala died on 10 June 1982. She had wanted to die in Púbol, and so the corpse was moved secretly, upright and wrapped tightly in a red dress, in her Cadillac, like *La Reine Morte* of Henri de Montherlant.

Dalí was made Marquis of Dalí and Púbol, it was announced on 20 July 1982. An immense exhibition of his works was placed on show in Madrid, then moved to Barcelona. Dalí stopped eating, and remained in Púbol, fed by a tube down his throat to his stomach. All of his possessions that had been left in Port Lligat – drawings and documents – were taken somehow by someone. There was no proof but much suspicion. The house was not guarded, and many things made their way into the black market. Now Dalí made a new will, leaving his entire estate to the Spanish nation. He also contacted Buñuel about making a film together, but the latter stated that he now never went out, and had given up the cinema. Buñuel died in July 1989.

Dalí's right hand continued to tremble, which, says Richardson, invalidates Robert Descharnes' claim that Dalí did 100 masterpieces between 1982 and 1983. They look like no others he had done before, and Gibson thinks they were done by Isidor Bea,

Dalí at the Hôtel Meurice.

his assistant. Dalí had hallucinations, thinking himself several animals, including a snail. From among his animal noises, his speech was impossible to understand, and he only said one comprehensible phrase: 'My friend Lorca.' The power of that memory of the beloved poet-friend overcame the weakness of the mind and body. It reminds me of Picasso at his end, conversing with his poet-friend Guillaume Apollinaire, who had been dead long since.

Looking after Dalí was more than difficult, given his screams and spitting and lunges at his caretakers' face with his long fingernails. On 30 August 1984 Dalí's bed caught fire; no one came when he called, and he was seriously injured. He was taken to the Pilar Clinic in Barcelona, but on the way he had to visit his museum in Figueres. 'Martyr-martyr' he repeated on entering the clinic. He left it on 17 October 1984, for the Torre Galatea in Figueres, which he was never to leave. Secrecy surrounded him, and his continual reminiscence about Lorca continued.

He never stopped believing in his destiny, and in his *Journal of a Genius*, for the entry of 1 May 1952, he spells it out grandly:

Yes, I believe I am the savior of modern art, the only one capable of sublimating, integrating, and rationalizing, imperially and beautifully, all the revolutionary experiences of modern times, in the great classic tradition of realism and mysticism which are the supreme and glorious mission of Spain.[2]

He died on 23 January 1989, and was buried under the cupola of his Teatre-Museu in a beige silk tunic embroidered with a large gold crown and a D for Dalí. Given his request that his face be covered in death, his fantastic novel *Hidden Faces* serves as a confirmation of life imitating art, in death at least. He himself had believed that he was a better writer than painter. I share that belief.

As testimony to the power of his writing, among all the other passages quoted here, I will end on the reflection in the *Vie secrète*

Dalí in 1989.

about his death, and the way it echoes the epilogue, in the *Diary of a Genius*, on 30 July 1941. There he is reflecting, aged thirty-seven, looking at himself in the mirror, with his hair black as ebony, no corns on his feet, having just finished the long book of his life. But in the middle of this reflection, he says: 'Ge suis tu nu et seul' ('I am completely naked and alone').

And in his *Vie secrète* he takes up that reflection again, so that his private manuscript of that secret life ends with this re-reflection, in his own orthography, of course:

And the morphological architecture of the scientific temple has all its windows open to heaven – Heaven! – here is what I have been looking for all along, and through all the demoniacal flesh of my life, heaven! / cursed be he who still hasn't understood that! . . . when I kiss Gala's mouth I am looking for heaven, and what is heaven, where is it? Heaven isn't found up or down, not to the right or left, heaven is found exactly in the center of the chest of the man who has faith!

END
Salvador Dalí Amton Mano
Exactly noon

Until this very moment I haven't yet had faith, and I fear dying without HEAVEN[3]

His Legacy, His Show, His Illusions

The legacy of Salvador Dalí is unquestionable and immense. Scarcely a day goes by without some reference, arcane or explicit, to him and his outlandishness, either by his own choosing or by someone else's. He cared greatly for his renown, and worked at it, as all the indications suggest: his carrying a bell to ring in case there was not sufficient notice taken of him (as two of my friends, Dore Ashton and Brian Nissen, described it to me), his outfits – or rather, costumes – his way of declaring and pulling at his moustaches. It was actually his work as well as his play – and that self-showingness was, and has always been, intensely important to the public awareness of the Dalí inheritance. See the museums devoted to him and Gala at Figueres, Port Lligat, Cadaqués, and so on . . .

See how his titles are overwhelmingly side-splitting, now as then: *Sistine Madonna (Quasi-grey Picture Which, Closely Seen, is an Abstract One; Seen from Two Yards is the Sistine Madonna of Raphael; and from Fifteen Yards is the Ear of an Angel Measuring One and One Half Yards)* of 1958. To say nothing of *The Perpignan Railway Station* (example opposite). See, of course, also, the way in which his studies and demonstrations, in so many paintings of the late 1930s, of paranoiac activity have not lost their relevance. He was constantly working out the contrast between the reality of our mind and our mental vision and the 'reality' of the external world, with his mysticism (which he was later to call 'nuclear

mysticism') working alongside his ceaseless passion for experimentation. See his *Endless Enigma* of 1938 in the Reina Sofía. And we have only to compare them with Jacques Lacan's thesis on paranoia of 1932 to see that what was in the air remains in the air: this overriding obsessional idea, the repetitive projection of the same events and personages, determines many of the works visual and verbal that we find most challenging today. Look anywhere, listen anywhere . . .

The exhibition organized by Michael Taylor at the Philadelphia Museum of Art in 2005 had a record-breaking attendance, with Dalí enthusiasts turned away each day. Many points of view about Dalí abound: I have enjoyed having them all available. For example, the take Robert Descharnes offers on Catalonia is itself to be

The Perpignan Railway Station (Gala Looking at Dalí in a State of Anti-Gravitation in His Work of Art 'Pop, Op, Yes-Yes, Pompier' in Which One Can Contemplate the Two Anguishing Characters from Millet's 'Angelus' in a State of Atavistic Hibernation Standing Out of a Sky Which Can Suddenly Burst into a Gigantic Maltese Cross Right in the Heart of the Perpignan Railway Station Where the Whole Universe Must Begin to Converge), 1965, oil on canvas.

treasured, on the Catalonians' taste for money (coming from their Phoenician ancestors) and for the actuality of life: 'A Catalonian accords existence only to what he can eat, hear, touch, smell, see.'[1] This is part of what Descharnes describes as 'Mediterranean materialism', and we assume this attitude is also responsible for the violence of colour in the paintings.[2] It is the landscape near Cadaqués we grow to sense, and to appreciate, with all the objects found near there and proliferating in Dalí's paintings: sea urchins, shells, stones, bones, skulls, marine organisms. Overall, a Catalonian heritage seems to supply 'a comestible delirium'.[3]

Descharnes mentions, with enormous enthusiasm, Dalí's fascination with 'such scientific advances as Bikini and the discoveries of modern physics, cybernetics, space adventure, hibernation, or DNA and the nucleic acids, the source of genetic memory'.[4] He and the painter were making a film together: *The Prodigious Story of the Lacemaker and the Rhinoceros*, in 1954–60, and working on the notion of stereoscopy and video. In fact, much of the present attraction to Dalí is based on the painter/photographer's experiments with optical illusion and with the scientific modes of thought, with such advances as laser technology, and the excitement of holograms – Dalí had a hologram exhibition at the Knoedler Gallery in New York in 1972, for which he and the physicist Dennis Gabor prepared the catalogue.

The important volume consecrated to optics and its science, *Dalí's Optical Illusions* edited by Dawn Adès, was based on a show held at the Wadsworth Atheneum from 21 January to 26 March 2000, and contains essays by Peter Sutton, Eric Zafran, Antonio Pichot and Montse Aguer. It contains a great number of reproductions of paintings especially valuable in this connection. Now it is already clear that in Dalí's adulation of the painters Vermeer, Velázquez, Raphael and Leonardo, there is an increasing emphasis on illusion and deception for the eye. Dalí was endlessly fascinated by the discoveries of modern science, and close in this as in many

ways to Marcel Duchamp, and his rejection of what he called the 'retinal frisson'.[5] His attitude was always scientific rather than metaphysical, and his connections with the Surrealist movement, before, during and after his actual participation in it, had to do chiefly with Surrealism's questioning of the empirical foundations of knowledge, with the junction and occasional opposition of realities internal and external. Everything photographic had an

The Infanta Margarita of Velázquez Appearing in the Silhouette of Horsemen in the Courtyard of the Escorial, 1982, oil on canvas.

enormous appeal for him, and Adès makes a comparison between Dalí's fascination with illusion and Walter Benjamin's 'unconscious optics'.[6] In fact Dalí's fascination with photography, as the genre that best captures the 'most delicate osmoses which exist between reality and surreality' does not replace but complements his fascination with film. I am thinking of the techniques in *Un Chien andalou*, such as the very close close-ups, the sequences in slow motion, the montage, the fades, the superimposition, the accelerated perspectives – and of his equal fascination with the sixteenth and seventeenth centuries' dabbling in anamorphosis, the famous book on which, Jurgis Baltrusaitis's *Anamorphoses, ou perspectives curieuses* (1969), was dedicated to him by the author. The work on perspectives is never devoid of passion for Dalí; perspectives never end for Dalí or for his readers: the very large and very amazing *Crucifixion*, for example, in all its startling perspectival madness hanging in the Metropolitan Museum of New York never fails to astonish.

Much of Dali's work, illustrated in the *Optical Illusions* volume, is based on the mode of thinking and principles of the mathematician René Thom, in his groundbreaking work on *Stabilité structurelle et morphogenèse*. Thom discusses three types of human activity: Art, Delirium and Play, making the distinctions quite clear.[7] And then Dalí waxes passionate about D'Arcy Wentworth Thompson, student of the succession of forms. Dalí reads compulsively about Catastrophe Theory, about morphogenesis, and about the 'topological structure of internal dynamism'.[8] Everything is enigmatic, old-timey clear and visionary at once. Take the *Three Glorious Enigmas of Gala* (1982), of which the second version is in the Fundació Gala at Figueres. It is a beautiful picture, with her face lucid as she lies on her side in the sand. The image, predicted by a 1931 work *Communication: Paranoiac Face*, a face that becomes a dome with three figures gathered around it, and then *Paranoiac Figure*, of 1934–5, in which her head lies against the sand, a few

rocks form her hair, and there are three figures stationed in each of the gaps in the large form. That form itself reads as critical because it is one of Dalí's last paranoiac critical double images, classical in form. Even Andy Warhol's 1960 experiments with the fixed camera in the façade of his Factory probably took their origin in Dalí's own inventiveness. Dalí had taught Antonio Pichot, the director of the Teatre-Museu in Figueres, to experiment with the fragments of rock at Cape Creus set at different angles, and Pichot is responsible, with Montse Aguer, for the last chapter in the book, 'Dalí's Permanent Provocation' in *Optical Illusions*. Pichot discusses Dalí's attraction to the optical, relating Dalí's attraction to the Dutch master Gerard Dou, author of one of the first stereoscopic experiments done by two versions of the same subject. This kind of experiment works like a pair of binoculars in which the use of mirrors adds to the illusion.[9] As an illustration, we are given Raphael's *Athens is Burning* (*The School of Athens* and *The Fire in the Borgo*), 1979–80, two frescoes in the Stanze of the Vatican, as two stereoscopic panels – not that Raphael was dealing in the kind of stereoscopy in which Dalí was involved. But for Dalí, 'when seen with the aid of angled mirrors, they spring into depth' [10] And he scatters over his replicas of the two paintings a series of coloured dots, reminding him perhaps of the optical theatre of his teacher, Señor Trayter, when he was very young.

Everything about the eye was of interest to Dalí, and of the way it could transcribe visions. In Hitchcock's film *Spellbound*, he created the dream sequence with all the eyes floating about, which reminds us of Odilon Redon's eyeballs airborne by balloons. Dalí even consulted, in the 1960s, a professor of optics about the possibility of inserting into the eye a thin lens with a liquid that would register the images occurring during sleep: pretty far out. A definite lyricism pervades the painter's writings on vision and envisioning. Take his response to an interview by himself (in principle, by a 'Felipe Jacinto', a pseudonym of Dalí himself):

I bear with me a precious apparatus which I invented two months ago and by means of which I will realize the greater part of my new pictures. Rather than a horrible, hard and mechanical photographic apparatus, it resembles a minuscule and tender apparatus of television in color. But the most wonderful thing! It is entirely soft! And as I looked at him with stupefaction, he added: 'Yes! An eye!'[11]

In his lecture of 17 December 1955, superlatively entitled 'Phenomenological Aspects of the Paranoiac-Critical Method', and given in the amphitheatre of the Sorbonne under a Puvis de Chavannes ceiling, Dalí made the delirious announcement that because 'France is the most intelligent country in the world, France is the most rational country in the world; on the contrary, I, myself, come from Spain, which is the most irrational country in the world and also the most mystical . . . Intelligence leads . . . us to the foggy nuances of skepticism . . . the gastronomical coefficient of super-gelatinous, Proustian, and gamy uncertainty.'[12] This irrationality combined with this intelligence certainly led Dalí to a number of his more astonishing works,[13] among which one of 1976 strikes me as both very Dalí and very apposite for a contemporary mode of looking at such work. The painting is provocatively entitled: *Dalí from the Back Painting Gala from the Back Eternized by Six Virtual Corneas Provisionally Reflected by Six Real Mirrors*. This painting for the right eye, copied from a stereoscopic photograph in black and white, is about perspective, stereoscopy, and the system of mirrors that Roger Lanne de Montebello set up and focused. Then in place of the too heavy glass, tightly stretched plastic film was used, supporting a higher power of refraction.[14] The confetti drifting over the reproductions and the squares of colour are meant to draw us into what Dalí terms a 'spiral axis'.[15]

Among the slew of optically oriented canvases, one of the most intriguing and long-lasting in its interest is that of the *Portrait of My Dead Brother* (1963), now found in the Salvador Dalí Museum in St Petersburg, Florida. It is a double picture in every sense, first about the brother who died nine months before his namesake's birth, the brother who had been called Salvador also, so that the painter always felt he was a second-comer, a substitute for the original Salvador Dalí. Enormous dots make up the brother's face, made of cherries. These molecules bear further witness to Dalí's passion for molecular chemistry. But when we look further, it turns out that a vulture, like the one Freud detected in Leonardo's *Virgin and Child with St Anne*, makes up the hair of the boy, and that the groups of figures behind the gigantic face represent Millet's *Angelus* (about which Dalí wrote so much) and also his *Winnower*, which haunts, along with the *Virgin and Child with St Anne*, Dalí's 'Interpretation Paranoiaque critique de l'image obsédante de "L'Angelus" de Millet'. It is as if everything were to gather in one painting, whose horizon leads out to much more. Which is the way Dalí's own horizons lead out, always to much more.

Along with his writing it remains his self-showmanship that has had the most impact on the observers of the current scene. Take his film *Soft Self-Portrait*, a self-portrait unequalled anywhere in delectable arrogance. He is, in that film as he was in life, a wizard at keeping himself on display, 'setting himself up – as a magician', as he says, so that his way of being a master of self-publicity is good for an appreciative chuckle anytime, if not for a guffaw. His innate love of intellectual subversion and systematic scandalizing of ordinary sensibility is continually on show, as he hatches out of an egg, visually demonstrates his own birth and that of Gala from one egg after their interuterine life, saws off the legs of a piano, tips it over and lets it sink as he is still playing. On his coat of black cloth are forty-one liquor glasses, on his head is a loaf of bread, and he pulls his moustache at us as it points right

Giant Dalí faces at the top of a staircase at Figueres.

and left at the world. But more importantly still, as he says, 'he paints the things that are behind things' – and in so doing, captivates his public and himself. He was already his own legacy, was nothing if not spectacular, and spectacular is exactly what he wanted to be.

Statue of Salvador Dalí on the beach at Figueres.

His Teatre-Museu in Figueres, near the landscape of Cadaqués he so loved, and the bizarre formations of Cape Creus, near Port Lligat and Púbol, is of course built on the premise that the more spectacular the better. The idea was dreamed up in the 1960s, to be built on the ruins of the old Municipal Theatre of Figueres, and it

A hall in the Teatre-Museu Dalí, Figueres, with a lifesize reconstruction of Dalí's *Face of Mae West which Can be Used as an Apartment* of 1943.

was completed in August 1974. Atop this edifice – the world's largest Surrealist object, as it bills itself – is a geodesic dome, constructed by Emilio Pérez Piñero. Inside are three divisions: the Teatre-Museu itself, the galleries (such as the Mae West Room –

Lapis Lazuli Cross made from gold, lapis lazuli, diamonds and rubies, from the Salvador Dalí Unique Jewellery Collection, Geneva, Switzerland.

a reconstruction of the *Face of Mae West which Can be Used as an Apartment* of 1943, and a room for the 1940 Cadillac, 'transformed into Rainy Taxi',[16] to say nothing of the naked form of Gala which turns into the face of Abraham Lincoln at twenty metres), and a

room for the Dalí-jewels, 39 of them, some crafted with moving parts like 'The Royal Heart', made of gold, rubies, diamonds and emeralds, whose centre actually beats. Not subtle, but spectacular.

I would agree with Ian Gibson that Dalí was at his best during the twelve years he shared the Surrealist spirit, from 1926 to 1938, when he 'created images of horror, mental unbalance and sexual alienation unlike anything being produced by other artists. His key scenario of the nightmare beach, with its eerie juxtaposition of assorted flotsam and jetsam, see-through rocks, stark shadows and sharp contours, its deep perspectives, its aridity and its anguished human presences – all painted in laborious detail – is one of our age's most unforgettable and disturbing icons, as Hitchcock was quick to perceive. Surely it will continue to haunt mankind.'[17]

But I think I should let the Divine Dalí have the last word. Here it is, from the Epilogue to his *Vie secrète:*

I want my voice to be listened to, I am the most representative incarnation of post-war Europe, I have known all the revolutionary the pseudorevolutionary reactionary and conservative tendencies, I have been a cubist protagonist of the surrealist and metaphysical experience . . . I don't want any of all that, I continue to want this unique thing, so simple, so difficult, so little desired – to grow old.[18]

References

Introduction

1. Salvador Dalí, *Hidden Faces*, trans. of *Visages cachés* byHaakon Chevalier (London, 1973), p. 301.
2. Ibid., p. 159.
3. Ibid., pp. 32–3.
4. Salvador Dalí, *La vie secrète de Salvador Dalí: Suis-je un genie?*, ed. Frédérique Joseph-Lowery (Lausanne, 2006).
5. Alyce Mahon, 'Tell me, Salvador Dalí, Are You God?', in *Persistence and Memory: New Critical Perspectives on Dalí at the Centennial*, ed. Hank Hine, William Jeffett and Kelly Reynolds (St Petersburg, FL, 2004), p. 46.
6. Antonio Pitxot and Josep Playà, *Gala Dalí's Castle: The Road to Púbol* (Figueres, 1997), p. 59.
7. Dalí, *Hidden Faces*, p. 162.
8. Sebastià Roig, *Dalí y El Triangulo de l'Empordà* (Figueres, 2003), pp. 102, 134.

1 Birth of a Genius, 1904–16

1. This Utrillo, interestingly enough, is the person who gave the more famous French painter Maurice Utrillo his name. When the extraordinarily beautiful model and painter Suzanne Valadon was about to have a baby, her friend and lover Miguel Utrillo asked who the father might be. Oh, Puvis de Chavannes or Auguste Renoir, Suzanne replied, or then . . . 'I don't really know.' So, said Utrillo,

since I so admire their works, I will sign the baby. Thus, the name of Maurice Utrillo.

2 Salvador Dalí, *Diary of a Genius*, trans. Richard Howard (London, 1990), p. 32.

3 Ibid., foreword by Michel Déon.

4 Alyce Mahon, 'Tell me, Salvador Dalí, Are You God?', in *Persistence and Memory: New Critical Perspectives on Dalí at the Centennial*, ed. Hank Hine, William Jeffett and Kelly Reynolds (St Petersburg, FL, 2004), p. 46.

5 Salvador Dalí, *The Secret Life of Salvador Dalí*, trans. Haakon M. Chevalier (New York and London, 1944), p. 74.

6 'Ge trouve toujours ce que ge cherche, l'ordre alfabetique net pas mon especialite et ge hu le don de toujours en etre deor, jalle donc me mete deor de l'ordre alfabetique d surrealisme puisque, que je le veille ou non, "le surrealisme ete moi".' (Salvador Dalí, *La vie secrète de Salvador Dalí: Suis-je un genie?*, ed. Frédérique Joseph-Lowery (Lausanne, 2006), p. 694.

7 Ibid., p. 161.

8 Ian Gibson, *The Shameful Life of Salvador Dalí* (New York, 1997), p. 61.

9 Dalí, *The Secret Life*, p. 34.

10 Ibid., p. 45.

11 Ibid., p. 138.

2 Precocious Painting, 1917–21

1 Ian Gibson, *The Shameful Life of Salvador Dalí* (New York, 1997), p. 87.

2 Salvador Dalí, *The Secret Life of Salvador Dalí*, trans. Haakon M. Chevalier (New York and London, 1944), p. 81.

3 Ibid.

4 Ibid.

5 Dalí, *The Secret Life*, p. 271.

6 Ibid., p. 381.

7 Ibid., p. 25.

8 Ibid., p. 90.

9 Ibid., p. 101.

10 Ibid., p. 321.

11 Ibid., p. 334.
12 Ibid., p. 179
13 Gibson, *The Shameful Life*, pp. 107–8.
14 Ibid., p.109.
15 Dalí, *The Secret Life*, p. 2.
16 Gibson, *The Shameful Life*, p. 102.
17 Ibid.
18 Dalí, *The Secret Life*, p. 145.

3 Madrid and La Residencia, 1922–26

1 Christopher Maurer, ed. and trans., *Sebastian's Arrows: Letters and Mementos of Salvador Dalí and Federico García Lorca* (Chicago, 2004), p. 61.
2. Salvador Dalí, *La vie secrète de Salvador Dalí: Suis-je un génie?*, ed. Frédérique Joseph-Lowery (Lausanne, 2006), p. 382.
3 Ian Gibson, *The Shameful Life of Salvador Dalí* (New York, 1997), p. 141.
4 Ibid., p. 142.
5 Ibid.
6 'Et qu'and ge sental le feu incendiaire et communicatif de la poesic du grand Federico monte en flames decoifes et foles, ge taich de les abatre avec la branch dolivie de ma viellesse premature d'anti-faus tout en preparant deja les grilles de mon prosaisme tracendental avec les qu'elles, le our venu, et q'and du feu inicial de Lorca n'enrestere que les bresses, ge viendrai griller sur /elle / les champignons les coteletes et les sardines de ma propre pense, lesquells / ge savai deja etai destinais a etre servi un jur, juste grilles au poin: /a fin detre servis cbien chodes/ sur les napes propes de la table du libre que vous etes en train de l'irc: a fin de venir apeser pendan une centene d'anes, la famine espirituelle imaginative moralle et idelogique de notre epoque'. Dalí, *La Vie secrète de Salvador Dalí*, p. 382.
7 Dalí, *The Secret Life*, p. 165.
8 Ibid., pp. 202–3.
9 Dalí, *The Secret Life*, p. 205.

4 St Sebastian: Dalí and Lorca, 1926–28

1 Christopher Maurer, ed. and trans., *Sebastian's Arrows: Letters and Mementos of Salvador Dalí and Federico García Lorca* (Chicago, 2004), p. 47.
2 Ibid., pp. 112–13.
3 Federico García Lorca, *Selected Letters*, trans. David Gershator (New York, 1984), p. 69.
4 Maurer, *Sebastian's Arrows*, p. 101
5 Ibid., p. 8.
6 Ibid., p. 9.
7 Ibid.
8 Ibid., p. 190.
9 Ibid.
10 Ibid.
11 Richard Kaye, 'Determined Raptures: St Sebastian and the Victorian Discourse of Decadence', in *Victorian Literature and Culture*, xv/1 (1999), p. 269.
12 Ibid., p. 270.
13 Maurer, *Sebastian's Arrows*, p. 57.
14 Ibid., p. 78.
15 Alain Bosquet, *Entretiens avec Salvador Dalí* (Paris, 1966), p. 54.
16 Maurer, *Sebastian's Arrows*, p. 184.
17 Ibid., p. 22
18 Ibid., p. 100.
19 Ibid.
20 Ibid., p. 104.

5 Dalí, Lorca and Catalunya, 1925–36

1 Text beneath a drawing of a mermaid offering a bowl of fruit, in a letter to Lorca. Quoted in Ian Gibson, *The Shameful Life of Salvador Dalí* (New York, 1997), p. 99.
2. Christopher Maurer, ed. and trans., *Sebastian's Arrows: Letters and Mementos of Salvador Dalí and Federico García Lorca* (Chicago, 2004), p. 175.

3 Ibid., p. 177.
4 Ibid., p. 40.
5 Ibid., p. 91.
6 Ibid.
7 Ibid., p. 62, and Gibson, *The Shameful Life*, p. 205.
8 Gibson, *The Shameful Life*, p. 206.
9 Gibson refers us to Meryl Secrest's writing that Dalí once said to Agnes Tanguy, the niece of Yves: 'I pinched everything from your Uncle Yves.' Gibson, *The Shameful Life*, p. 212; Meryl Secrest, *Salvador Dalí* (New York, 1986), p. 87.
10 Gibson, *The Shameful Life*, p. 214.
11 Ibid., p. 112.
12 Ibid., p. 206.
13 Ibid., p. 213.
14 Maurer, *Sebastian's Arrows*, p. 174.
15 Ibid., p. 214.
16 Gibson, *The Shameful Life*, p. 214; Salvador Dalí, *The Secret Life of Salvador Dalí*, trans. Haakon M. Chevalier (New York and London, 1944), p. 221.

6 Miró, Dalí and Surrealism, 1928

1 Christopher Maurer, ed. and trans., *Sebastian's Arrows: Letters and Mementos of Salvador Dalí and Federico García Lorca* (Chicago, 2004), p. 175.
2. Ian Gibson, *The Shameful Life of Salvador Dalí* (New York, 1997), p. 236.
3 Dawn Adès, *Dalí* (London, 1982), p. 142.
4 Maurer, *Sebastian's Arrows*, p. 104.
5 A particularly cogent discussion of this entire set of paintings and images can be found in *The Collected Writings of Salvador Dalí*, ed. and trans. Haim Finkelstein (London and New York, 1998), pp. 122ff.
6 See Finkelstein above.
7 Adès, *Dali*, p. 153.
8 Salvador Dalí, *The Secret Life of Salvador Dalí*, trans. Haakon M. Chevalier (New York and London, 1944), p. 237.
9 Ibid., p. 268.

10 Ibid., p. 222.
11 Ibid., p. 312.
12 Ibid., p. 319.
13 Ibid., p. 325.
14 Ibid., p. 379.

7 Buñuel and the Cinema, 1929

1 Ian Gibson, *The Shameful Life of Salvador Dalí* (New York, 1997), p. 243.
2 Ibid., p. 244.
3 In Haim Finkelstein, *Salvador Dali's Art and Writing, 1927–1942* (Cambridge, 1996), p. 165.
4 Gibson, *The Shameful Life*, p. 249.
5 Ibid., p. 261. Gibson cites Desnos in *Le Merle*, Paris, 28 June 1929.
6 Finkelstein, *Salvador Dali's Art and Writing*, p. 122.
7 Ibid.
8 Salvador Dalí, *La vie secrète de Salvador Dalí: Suis-je un génie?*, ed. Frédérique Joseph-Lowery (Lausanne, 2006), p. 76.
9 Ibid., p 77.
10 Gibson, *The Shameful Life*, p. 249.
11 I am contrasting here, as all the way through this biography, the version of *The Secret Life of Salvador Dalí*, trans. Haakon M. Chevalier (New York and London, 1944), which is a translation from Gala's edition, as it were, and the recently appeared Dalí, *La Vie secrète de Salvador Dali: Suis-un génie?*, in which Dalí's own phrasing and spelling are visible and delightfully so.
12 Finkelstein, *Salvador Dali's Art and Writing*, p. 97.

Intermission: Filmic Dalí

1 J.G. Ballard, *Guardian*, 6 May 2007.
2 Laura Cummings, 'Dalí and Film', *Guardian*, 3 June 2007.
3 Richard Schickel, *Los Angeles Times*, 14 October 2007, reviewing Matthew Gale, *Dalí and Film*.
4 See http://www.lacma.org/art/BehindtheScenesDali.aspx.

8 Paris, Surrealism and Gala, 1929–30

1 Haim Finkelstein, ed. and trans., *Collected Writings of Salvador Dalí* (London and New York, 1998), p. 263.
2 Ibid., p. 108.
3 In 'Filmarte, film-antiartistico', *Gazeta Literària* (Madrid), no. 24, 15 December 1929, p. 8, cited in ibid., p. 220.
4 'Reality and Superreality', *Gazeta Literària* (Madrid), no. 44, 15 October 1928, p. 7, cited in Finkelstein, *Collected Writings*, p. 226.
5 Ibid., p. 225.
6 'Poem of the Little Things', *L'Amic de les Arts* (Sitges), no. 27, 31 August 1928, p. 211.
7 'Filmarte, film-antiartistico', *Gazeta Literària* (Madrid), no. 24, 15 December 1929, p. 8., cited in Finkelstein, *Collected Writings*, p. 220.
8 'Poetry of Standardized Utility', *L'Amic de les Arts* (Sitges) no. 23, 31 March 1928, pp. 176–7, cited in Finkelstein, *Collected Writings*, p. 223.
9 Gibson, *The Shameful Life*, p. 305.
10 Ibid., p. 324.
11 Salvador Dalí, *The Secret Life of Salvador Dalí*, trans. Haakon M. Chevalier (New York and London, 1944), p. 284.

9 Fame Beginning, 1931–32

1 Haim Finkelstein, ed. and trans., *Collected Writings of Salvador Dalí* (London and New York, 1998), p. 138.
2 My translation from Dalí's *La Vie secrète de Salvador Dalí: Suis-je un génie?*, ed. Frédérique Joseph-Lowery (Lausanne, 2006), p. 548.

10 Fame Increasing, Exhibitions Continuing, 1932–36

1 Gertrude Stein, *Everybody's Autobiography* (New York, 1973), pp. 17–18.
2 'Déjà la iene de l'opinion publique rode autour de moi', he says, demanding 'que ge me decide infin, que ge deviene ou Estalinien ou Itlerien, NO! NON! NON! Et cent fois non! Jaller continuer a etre com

toujour, et jusqu'a ma mort Dalinien et seulement Dalinien!' Salvador Dalí, *La vie secrète de Salvador Dalí: Suis-je un génie?*, ed. Frédérique Joseph-Lowery (Lausanne, 2006), p. 662.

Intermission: The Genius of Detail

1 Salvador Dalí, *The Secret Life of Salvador Dalí*, trans. Haakon M. Chevalier (New York and London, 1944); Salvador Dalí, *La vie secrète de Salvador Dalí: Suis-je un génie?*, ed. Frédérique Joseph-Lowery (Lausanne, 2006).
2 Dalí, *La vie secrète*, p. 161.
3 Dalí, *The Secret Life*, p. 126.
4 Ibid., pp. 273–4.
5 *La Vie secrète*, pp. 550–51.
6 Haim Finkelstein, *Salvador Dali's Art and Writing, 1927–1942* (Cambridge, 1996), p. 78.
7 Salvador Dalí, 'Photography, pure creation of the mind', in *L'Amic de les Arts* (Sitges), no. 18, 30 September 1927, pp. 90ff.
8 Dalí, *The Secret Life*, p. 75.
9 Salvador Dalí, 'Poetry of Standardized Utility', *L'Amic de les Arts* (Sitges), no. 25, March 1928, pp. 176–7.
10 Dalí, *The Secret Life*, p. 84.
11 Dalí, *La Vie secrète*, p. 78.
12 Dalí, *Secret Life*, p. 9.
13 Ibid., p.38.

11 Lorca Dead, Narcissus Alive, 1936–38

1 Salvador Dalí, *The Secret Life of Salvador Dalí*, trans. Haakon M. Chevalier (New York and London, 1944), p. 361.
2 Ian Gibson, *The Shameful Life of Salvador Dalí* (New York, 1997), pp. 428–9.
3 Ibid., p. 430.
4 Salvador Dalí, *La vie secrète de Salvador Dalí: Suis-je un génie?*, ed. Frédérique Joseph-Lowery (Lausanne, 2006), p. 93. The editor notes

that this is the pronunciation of Freud in Catalan, and that Dalí saw a death's head in Freud's face (see p. 95).

5 Haim Finkelstein, 'Dalí's Small Stage of Paranoiac Ceremonial', in *Companion to Spanish Surrealism*, ed. Robert Havard (Woodbridge, Suffolk, 2004), p. 117.

6 Ibid., p. 130.

7 Ibid., p. 131.

8 James Elkins, *Poetics of Perspective* (Ithaca, NY, 1994), p. 154.

9 See Haim Finkelstein, 'Dalí: Espace et perspective', in *Salvador Dalí à la croisée des savoirs*, ed. Astrid Ruffa, Philippe Kaenel and Danielle Chaperon (Paris, 2007), pp. 159–72, and Haim Finkelstein, ed. and trans., *Collected Writings of Salvador Dalí* (London and New York, 1998), p. 135.

10 Claude Gandelman, *Reading Pictures, Viewing Texts* (Bloomington, IN, 1991), p. 25. Cited in Finkelstein, 'Dalí's Small Stage', p. 117; also in 'Dalí's Theater: Elements of Mannerism and the Baroque', in *Dalí's Medienspiele*, ed. Isabel Maurer Quiepo and Nanette Risler-Pipka (Bielefeld, 2006), pp. 224–5.

11 Haim Finkelstein, 'Dalí: Espace et perspective', p. 137; *Collected Writings*, p. 167.

12 Ibid., p. 168.

13 Ibid.

12 America's Dalí, 1939–48

1 Salvador Dalí, *La vie secrète de Salvador Dalí: Suis-je un génie?*, ed. Frédérique Joseph-Lowery (Lausanne, 2006), p. 686.

2 Ibid., p. 687.

3 Ibid.

4 'Ge considere alors froAdemenet la cituation, et juge baucoub plus raisonable de partir par le trou/ de la vitre / erisse /des/ estalactites et des estalagmites de ma colere . . .' Ibid., p. 688.

5 'Et au lieu de cela on m'aporte tout le temps des horribles costumes de sirens avec des queux de poison en cautchuc!' Ibid.

6 Ibid., p. 690.

7 Haim Finkelstein, 'Dalí: Espace et perspective', in *Salvador Dalí à la*

croisée des savoirs, ed. Astrid Ruffa, Philippe Kaenel and Danielle Chaperon (Paris, 2007), p. 168.

8 Ibid., p. 251.

9 Ibid., p. 165.

10 *La Vie secrète*, p. 694.

11 Ian Gibson, *The Shameful Life of Salvador Dalí* (New York, 1997), p. 109.

12 See Eric M. Zafran, 'Salvador Dalí in Hartford', in *Dali's Optical Illusions*, ed. Dawn Adès (New Haven, CT, and London, 2000), pp. 38–61.

13 Ibid., p. 44.

14 Ibid., p. 54.

15 Salvador Dalí, *The Unspeakable Confessions of Salvador Dalí* (New York and London, 1976), p. 34, cited in Adès, ed., *Dalí's Optical Illusions*, p. 15.

16 Salvador Dalí, *Hidden Faces*, trans. Haakon Chevalier (London, 1973), p.17. It was translated on the estate of the Marquis de Cuevas in New Hampshire.

17 Ibid., p. 28.

18 Ibid., p. 32, for all the above quotations.

19 Ibid., p. 34.

20 Ibid., p. 143.

21 Ibid., p. 162.

22 Ibid.

23 Ibid., p.168.

24 Ibid., p. 303.

25 Ibid.

26 Edmund White, 'Salvador Dalí as Novelist', *New Yorker*, 1 July 1944, pp. 61–2, 65, cited in Haim Finkelstein, *Salvador Dalí's Art and Writing, 1927–1942* (Cambridge, 1996), p. 308.

27 Ian Gibson, *The Shameful Life*, p. 496.

28 Ibid., p. 499.

29 Ibid., p. 672.

13 Back Home, 1948–51

1 Haim Finkelstein, *Salvador Dalí's Art and Writing, 1927–1942* (Cambridge, 1996), p. 263.

2 Ian Gibson, *The Shameful Life of Salvador Dalí* (New York, 1997), p. 513.

3 Salvador Dalí, *Journal d'un génie* (Paris, 1964), p. 85.

4 Salvador Dalí, *The Secret Life of Salvador Dalí*, trans. Haakon M. Chevalier (New York and London, 1944), p. 302.

5 Ibid., p. 521.

6 Ibid.

7 Miguel Utrillo, *Salvador Dalí y sus enemigos* (Sitges, 1952), p. 15. Anna Maria's book, *Salvador Dalí Seen by his Sister*, he describes as 'a book which will be remembered only as an example of what can be achieved by an atrophied femininity'. Cited in Gibson, *The Shameful Life*, p. 523.

8 Gibson, *The Shameful Life*, p. 523.

Intermission: Magic Secrets of Painting

1 Salvador Dalí, *50 Secrets of Magic Craftsmanship*, trans. Haakon M. Chevalier (New York, 1948).

2. Ibid., p. 9.

3 Ibid.

4 Ibid., p. 19.

5 Ibid.

6 Ibid., pp. 71–2.

7 Ibid., pp. 36–8.

8 Ibid., pp. 36–8.

9 Ibid., p. 38.

10 Ibid., pp. 63–4.

11 Ibid.

12 Ibid., p. 73.

13 Ibid., p. 79.

14 Ibid., p. 93.

15 Ibid., pp. 73–4.

16 Ibid., p. 101.

14 Winning the Battle, 1952-60

1 Ian Gibson, *The Shameful Life of Salvador Dalí* (New York, 1997), p. 523.
2 Haim Finkelstein, *Salvador Dalí's Art and Writing, 1927–1942* (Cambridge, 1996), p. 231.
3 Robert Descharnes, *Salvador Dalí*, p. 182.
4 Salvador Dalí, *Journal d'un génie* (Paris, 1964), p. 65.
5 Ibid., p. 300.
6 John Richardson, 'Dalí's Gala', in *Sacred Monsters, Sacred Masters* (New York, 2001), p. 298.
7 Ibid., p. 291.

15 Scandals and Seclusion, 1960–79

1 Haim Finkelstein, *Salvador Dalí's Art and Writing, 1927–1942* (Cambridge, 1996), p. 247.
2 Salvador Dalí, *Journal d'un génie* (Paris, 1964), p. 215.
3 John Richardson, 'Dalí's Gala', in *Sacred Monsters, Sacred Masters* (New York, 2001), p. 292.
4 Ibid.
5 Ibid., pp. 243–83.
6 Salvador Dalí, *The Secret Life of Salvador Dalí*, trans. Haakon M. Chevalier (New York and London, 1944), p. 350.
7 Ibid.
8 Gibson, *The Shameful Life*, p. 580.
9 Ibid.
10 Ibid., p. 637.
11 Ibid., p. 619.

16 Endings, 1980–89

1 Salvador Dalí, *La vie secrète de Salvador Dalí: Suis-je un génie?*, ed. Frédérique Joseph-Lowery (Lausanne, 2006), p. 662.
2 Salvador Dalí, *Journal d'un génie* (Paris, 1964), p. 45.

3 'Et l'architecture morfhologique du temple cientifique a toutes ces fenetres ouverte au ciel – Le ciel!, voAla ce que ge recherche tout au l'ong, et a travers toute la chair demoniaque de ma vie, le ciel! /malereux qui n'aura pas encore conpris cela! . . . quant genbrasse la bouche de Gala gi cherche le ciel, et quesque cet que le siel ou ce trouve t'il? Le ciel ne ce trouve ni en aut ni en vas, ni a droite, ni a gauche, le ciel se trouve exactement au centre de la poatrine, de l'ome qui a la Foi!'

17 His Legacy, His Show, His Illusions

1 Robert Descharnes, *Salvador Dalí*, trans. Eleanor R. Morse (New York, 1976), p. 28.
2 Ibid.
3 Ibid., p. 11.
4 Ibid.
5 Dawn Adès, ed., 'Dalí's Optical Illusions', in *Dalí's Optical Illusions* (New Haven, CT, and London, 2000), pp. 10–11, quoting from Pierre Cabanne, *Entretiens avec Marcel Duchamp* (Paris, 1995), p 74.
6 Walter Benjamin, *Illuminations* (New York, 1969), p. 239, cited in Adès, 'Dalí's Optical Illusions', p. 13.
7 René Thom, *Stabilité structurelle et morphogenèse* (Boston, MA, 1972). The penultimate illustration in *Optical Illusions* – Dalí's *Topological Contortion of a Female Figure* (1983), which looks like a humanized Moebius strip, the legs forming one of the swoops of the figure (p. 193) – is dedicated 'To Thom'.
8 *Optical Illusions*, pp. 190–91.
9 Ibid., p. 63.
10 Ibid., pp. 184–5.
11 Quoted in ibid., p. 15., from 'The Last Scandal of Salvador Dalí', exhibition catalogue for *Salvador Dalí*, Arts Club of Chicago, 1941.
12 Descharnes, *Salvador Dalí*, p. 45.
13 John Richardson, 'Dalí's Gala', in *Sacred Monsters, Sacred Masters* (New York, 2001), p. 302.
14 Descharnes, *Salvador Dalí*, p. 168.
15 Ibid., pp. 184–5.

16 Ibid, p. 64.

17 Ian Gibson, *The Shameful Life of Salvador Dalí* (New York, 1997), p. 687.

18 'Ge veau que ma voi soit ecoute, ge suis l'incarnation la plus represen-
 tative de l'Erope de la post guerre ge conu toutes les tendances revolu-
 tionaries psdorevoltionaires reactionaire et consevatives, ge ete
 protagoniste/cubiste/de l'experience surrealiste,/metafhisique . . .
 ge ne veux veux pas de tout cela, ge continue a vouloir cette hunique
 chosse si simple, si dificile si peut desire, veillir'. Salvador Dalí, *La vie
 secrète de Salvador Dalí: Suis-je un génie?*, ed. Frédérique Joseph-Lowery
 (Lausanne, 2006), p. 737.

Bibliography

Adès, Dawn, *Dalí* (London, 1982; repr. 1990)
——, ed., *Dali's Optical Illusions* (New Haven, CT, and London, 2000)
Dalí, Salvador, *The Secret Life of Salvador Dalí*, trans. Haakon M. Chevalier
 (New York and London, 1944)
——, *La vie secrète de Salvador Dalí: Suis-je un génie?*, ed. Frédérique Joseph-
 Lowery (Lausanne, 2006)
——, *Journal d'un génie* (Paris, 1964)
——, *Diary of a Genius*, trans. Richard Howard (London, 1990)
——, *Hidden Faces*, trans. Haakon Chevalier (London, 1947)
——, *50 Secrets of Magic Craftsmanship*, trans. Haakon M. Chevalier (New
 York, 1948)
Descharnes, Robert, *Salvador Dalí*, trans. Eleanor R. Morse (New York, 1976)
——, *Salvador Dalí: The Paintings, 1904–1946* (Cologne, 1997)
Elkins, James, *Poetics of Perspective* (Ithaca, NY, 1994)
Finkelstein, Haim, ed. and trans., *Collected Writings of Salvador Dalí* (London
 and New York, 1998)
——, 'Dalí: Espace et perspective', in *Salvador Dalí à la croisée des savoirs*,
 ed. Astrid Ruffa, Philippe Kaenel and Danielle Chaperon, (Paris, 2007)
——, *The Screen in Surrealist Art and Thought* (Aldershot and Burlington,
 VT, 2007)
——, 'Dalí's Small Stage of Paranoiac Ceremonial', in *Companion to Spanish
 Surrealism*, ed. Robert Havard (Woodbridge, Suffolk, 2004)
——, 'Dalí's Theater: Elements of Mannerism and the Baroque', in *Dalí's
 Medienspiele*, ed. Isabel Maurer Quiepo and Nanette Risler-Pipka
 (Bielefeld, 2006)
Gale, Matthew, ed., *Dalí and Film* (London, 2007)
Gandelman, Claude, 'The Gesture of Demonstration', in *Reading Pictures,*

Viewing Texts (Bloomington, IN, 1991)

Gibson, Ian, *The Shameful Life of Salvador Dalí* (New York, 1997)

Kaye, Richard, 'Determined Raptures: St Sebastian and the Victorian Discourse of Decadence', in *Victorian Literature and Culture*, XXVII/1 (1999), pp. 269–303

Mahon, Alyce, 'Tell me, Salvador Dalí, Are You God?', in *Persistence and Memory: New Critical Perspectives on Dalí at the Centennial*, ed. Hank Hine, William Jeffett and Kelly Reynolds (St Petersburg, FL, 2004)

Maurer, Christopher, ed. and trans., *Sebastian's Arrows: Letters and Mementos of Salvador Dalí and Federico García Lorca* (Chicago, IL, 2004)

Pitxot, Antonio, and Josep Playà, *Gala Dalí's Castle: The Road to Púbol* (Figueres, 1997)

Richardson, John, 'Dalí's Gala', in *Sacred Monsters, Sacred Masters* (New York, 2001)

Roig, Sebastià, *Dalí y El Tríangulo de l'Empordà* (Figueres, 2003)

Rojas, Carlos, *Salvador Dalí: Or the Art of Spitting on your Mother's Portrait*, trans. Alma Amell (University Park, PA, 1993)

Secrest, Meryl, *Salvador Dalí* (New York, 1986)

Taylor, Michael, *The Dalí Renaissance: Perspectives on his Life and Art after 1940* (New Haven, CT, 2008)

Thom, René, *Stabilité structurelle et morphogénèse* (Boston, MA, 1972)

Acknowledgements

The recent publication of the original manuscript of *La Vie secrète de Salvador Dali: Suis-un génie?* in a scholarly edition by Frédérique Joseph-Lowery (Lausanne, 2006) has meant the rethinking of the *Secret Life* as edited by Gala Dalí and translated by Haakon Chevalier. I have tried to use both versions according to what seemed most appropriate for the narrative. As concerns the *Journal d'un génie* (Paris, 1964), I have used passages in my own translation, referring to them as the *Journal of a Genius* to distinguish these from *Diary of a Genius* (London, 1966).

I want to acknowledge my immense debt to Ian Gibson's *The Shameful Life of Salvador Dali* (New York, 1997), and to Haim Finkelstein's *Collected Writings of Salvador Dalí* (London and New York, 1998). For the friendship of the latter author, I am deeply grateful.

In the preparation of this book, I was greatly helped by conversations with several friends, and in my visit to Dalí country, by new friends there – I want to thank them all right here: Dawn Adès, Dore Ashton, Ramon Duran and the staff of the Hotel Duran (Figueres), Jane Isay, Frédérique Joseph-Lowery, Brian Nissen, Lee Pennington, Jack Spector, Michael Taylor, Juame Subiros and the staff of the Restaurant Empordà (Figueres). And my thanks to Michael Leaman for having invited me to undertake this book and to Harry Gilonis, as always, for his help with the visual part.

Photo Acknowledgements

The author and publishers wish to express their thanks to the following sources of illustrative material and / or permission to reproduce it (some locations of artworks are also given below):

Photos author: pp. 10, 15, 22, 24, 30, 166, 167; photo CROLLALANZA / Rex Features: p. 169; photos Everett Collection / Rex Features: pp. 6, 88; Fukuoka Art Museum, Japan: p. 125; Fundació Gala-Salvador Dalí, Figueres: pp. 46, 120, 161; photos courtesy of the Fundació Gala-Salvador Dalí, Figueres: pp. 34, 109, 128, 168; Fundación Federico García Lorca, Madrid: p. 39; Haggerty Museum of Art, Marquette University, Milwaukee: p. 124; photos KPA / Zuma / Rex Features: pp. 127, 142; Library of Congress, Washington, DC (Prints and Photographs Collection): p. 121; photo © Henri Martinie / Roger-Viollet / Rex Features: p. 83; Moderne Pinakotek, Munich (Bayerische Staatsgemäldesammlungen): p. 35; Musée National d'Art Moderne, Paris: p. 68; Museo Nacional Centro de Arte Reina Sofia, Madrid: pp. 26, 42, 52; Museu Nacional d'Art de Catalunya, Barcelona (Museo de Arte Moderno): p. 19; Museum Boymans Van Beuningen, Rotterdam: p. 101; Museum Ludwig, Köln: p. 159; Philadelphia Museum of Art: p. 90; private collections: pp. 27, 76, 80, 96, 112; from *La Revolution surrealiste*, 11, 1928: p. 59; photos © Roger-Viollet, courtesy of Rex Features: pp. 140, 149, 150; © Salvador Dali, Gala-Salvador Dalí Foundation, DACS, London 2008: pp. 10, 19, 26, 27, 34, 35, 39, 42, 52, 68, 80, 90, 96, 101, 109, 112, 115, 116, 120, 124, 125, 128, 133, 148, 159, 161, 166, 167, 168; on loan to the Salvador Dalí Museum, St Petersburg, Florida: p. 148; photos © SIPA Press / Rex Features: pp. 17, 147, 154, 156; photo James Thrall Soby: p. 116; photo © Studio Lipnitzki / Roger-Viollet / Rex Features: p. 139; Teatre-Museu Dalí, Figueres: pp. 34, 109, 128; Wadsworth Atheneum Museum of Art,

Hartford, CT: p. 115; photo courtesy of the Wadsworth Atheneum Museum of Art Achives: p. 116.

St. Louis Community College
at Meramec
LIBRARY